INDIAN SCULPTURE

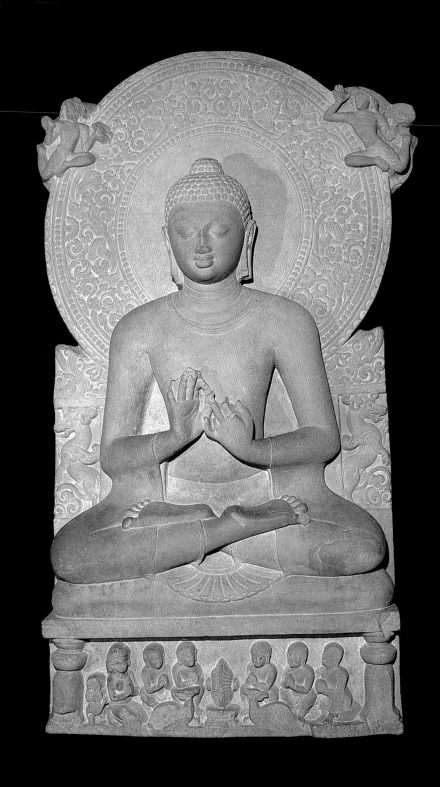

INDIAN SCULPTURE

~

GRACE MORLEY

PHOTOGRAPHS BY
DN DUBE

FOREWORD BY
KAPILA VATSYAYAN

Lustre Press
Roli Books

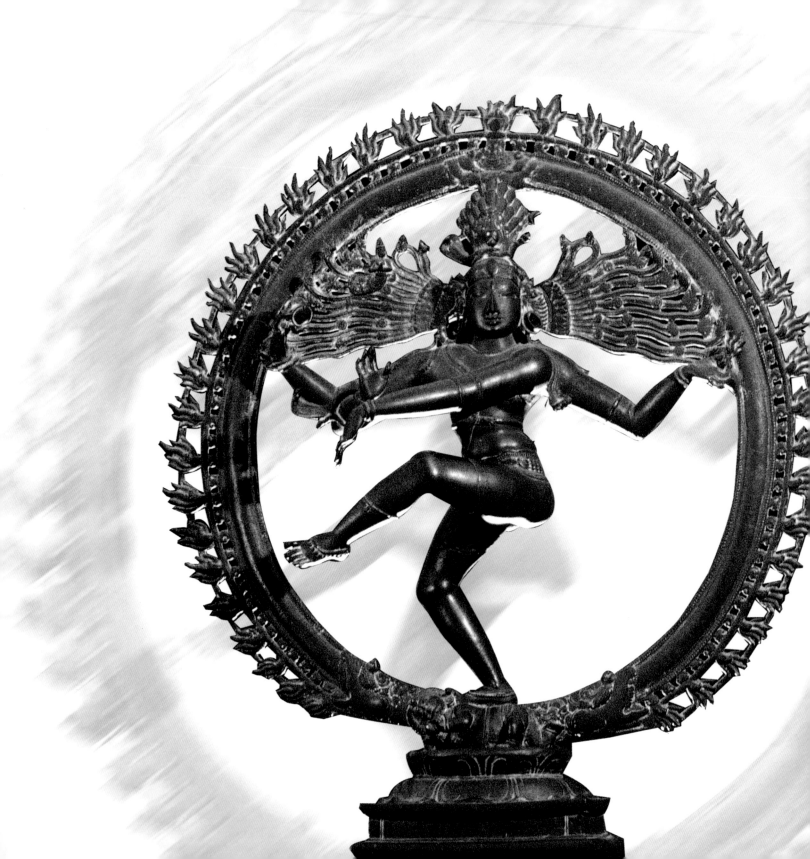

CONTENTS

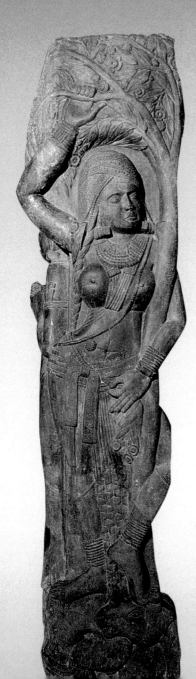

ISBN: 81-7436-352-1

Editor: Dipa Chaudhuri
Design: Arati Subramanyam
Layout: Naresh Mondal, Kumar Raman
Production: Naresh Nigam

© **Roli & Janssen BV 2005**
Second impression 2006
Published in India by Roli Books
in arrangement with Roli & Janssen BV
M-75 Greater Kailash II (Market), New Delhi 110 048, India
Ph: ++91-11-29212782, 29210886 Fax: ++91-11-29217185
E-mail: roli@vsnl.com Website: rolibooks.com

Printed and bound in Singapore

FOREWORD

Gracious Grace, ripe, rich and mellow is no longer with us and yet her presence permeates the halls and corridors of museums and institutions throughout India, Southeast Asia and the Far East. Museums in the United States of America, Europe and Mexico also carry the imprint of her life's work.

For me, Grace was friend, guide and philosopher, confidante, mentor and exacting master from the moment she arrived in India. Gentle as she was, Grace was nevertheless a symbol of flinty inner courage; a visionary who could concretize her dreams through unmatched precision.

My memory travels far into the past. It seems only yesterday, though it was almost five decades ago, that I visited the Museum of Modern Art, San Francisco. An exhibition of the latest works of Henri Matisse sprawled over the spacious walls of the museum; its gray and brilliant blues left a deep impression on me. Visiting this museum was a great change from my many months of wandering around England's Victoria & Albert, the Metropolitan in New York and the Detroit Museum.

The idea of space and light in a museum had never occurred to me until I entered the museum in San Francisco. It aroused in me an insatiable hunger for visiting museums of modern art in Europe, especially the Museum of Modern Art in Paris. I asked many which was the best and in reply came only one answer: San Francisco. The museum and its galleries were the work of a lady named Dr Grace Morley. She was known for her imagination and her exacting standards; an extraordinary scholar, she was said to be thorough, but inaccessible, and in short, the prototype of the professionally competent woman, much admired and a trifle dreaded.

While the impression was strong and lasting in the intervening years, it receded into the grooves of my memory. Many years had elapsed. Moti Chandra had come and gone, others who had followed could not visualize a truly National Museum for India. An international search for a suitable director resulted in the fortuitous circumstance of Dr Morley's arriving in India after years of valuable work for UNESCO in Paris, Mexico and elsewhere. One fine morning I met her and then the memories of the visit to the Museum of Modern Art in San Francisco and its director's reputation were reawakened.

I had heard from friends she was unapproachable, aloof and an exacting taskmaster. As I now sat and heard her speak with a senior colleague, I wondered whether this was the same person. Here was a kind and gracious human being, who appeared generous but unsure of the

nature of the task which lay before her in this strange, bewildering land. Many doubts were raised, in public and in private. How would a non-Indian, a specialist in modern art or Mexican art be able to guide the destinies of a museum of Indian ancient and medieval art? Would she not be better suited to head the National Gallery of Modern Art? These and many other rumblings continued in Delhi circles, until one by one, each doubt and voice of skepticism was silenced and the National Museum acquired a character, a body and shape which in no small measure is the gift of Grace Morley to India. Years of arrears of accessions were cleared, photo index-cards introduced, cataloguing and documentation on scientific lines begun, conservation work launched and display galleries transformed beyond recognition in the course of two or three years.

Her international contacts with Paris, Mexico and Rome brought in specialists of all aspects of museology. There was Plenderlieth from Rome, others from Paris, the United States and Mexico. Her great ambition was to put India with its vast and valuable art treasures on the world map. Assiduously she trained many younger colleagues, not only of the National Museum but from practically all other museums of India, in techniques of conservation, cataloguing, documentation and display. The fact that today India can be proud of an entire generation of competent museologists is to a large extent the result of Grace's single-handed initiative, drive and tenacity. Throughout she was as anxious to build institutions as to foster the growth of

human resources, each time identifying with uncanny discernment the specific potential and then presenting opportunities for both challenge and eventual recognition. It was clear that Grace was a museum person first and last, and thus the specific areas of ancient or modern art, ethnology or science, textiles or jewellery were only a matter of responding to particular needs rather than just being a subject specialist in the field.

Having watched her in operation emboldened me to request her to present two exhibitions on the occasion of the XXVIth International Congress of Orientalists held in India in January 1964. One of them was particularly exacting. An exhibition of Indian manuscripts for the august body of Oriental scholars from all parts of the world had to be presented. As the first session of this conference ever held east of Suez, this was a challenging organizational task. Grace helped and guided in every detail but most of all in the exhibition. The catalogue was a difficult matter. I watched her guide and direct its preparation and publication. She was both tireless and exacting, and I remember clearly the manner in which she brought enthusiasm and hope at moments when others felt a great dejection and a sense of hopelessness of achieving the targets.

Soon after this I had my really intense orientation under her stewardship. The Teen Murti House was to be converted into the Nehru Museum, innumerable polyvalent skills were required to make a home into a national museum. Although I was not her formal student, in six weeks she transformed me into a pupil, or may I say a

disciple, and I have so remained. Her sense of detail, her anticipation of problems, her ability to chalk out plans was as impressive as it was educative. Above all, her zeal and her energy and stamina put all of us, years her juniors in age, to shame, utter shame. For this experience and the training imbibed, I am beholden.

Since then, there were other such valuable occasions, too numerous to be recounted. Each provided an experience to learn and to receive from her, both in the context of the National Museum and elsewhere. Throughout, I was staggered by her capacity for identifying herself wholly with an institution or a human being's welfare, and striving in all possible ways to find solutions. Such a capability is given only to a selfless person: Grace had it in ample measure. Understandably, she earned the appellation of 'Mataji' from many of her Indian sons and daughters.

A discerning student of Western art and music, she was an avid reader and most knowledgeable in her response to the beauties of Indian architecture, sculpture, painting, music and dance. The Kashmiri shawl was an old love of hers, which the Indian experience rekindled and extended to textiles in general. She was perhaps the stoutest spokesperson for the collections of the Bharat Kala Bhavan and Calico Museum. Her impeccable taste in texture, design and colour was evident in her choice of materials and fabrics—in furnishing and garments—both in the house and in the museum.

For me, all this and her enthusiasm for the heritage of Southeast Asia (where I have had the opportunity to be her travelling companion) was an enriching, eye-opening experience. I remember the delight on her face watching the Ramayana Panels in Prambanan, Indonesia, and her enthusiastic and sensitive response to the arts of Bali. She was responsible for guiding the destinies of the National Museum, Thailand, and the conservation work at Pagan, Burma. Everywhere she earned the reputation of a fairy whose magic wand would find solutions. But those solutions were the results of perseverance, tenacity and ceaseless effort for the cause of the preservation of the cultural heritage of South Asia. She was committed to presenting it before the international community of museums. Her contributions in creating channels of communication amongst professionals of the area will have far-reaching effects in years to come.

Grace had many other passions. The field of scientific conservation was close to her heart and I watched her stress the need for a separate institution with a gentle but firm tenacity. Her inspiration and work ultimately led to the foundation of a separate National Conservation Laboratory for Cultural Property. She was equally passionate about science museums. She travelled far and wide in the interior to help establish small science museums. The Birla Science Museum in Kolkata, the Visesvaraya Industrial and Technological Museum in Bangalore, the Science Museum in Mumbai are deeply indebted to her guidance.

Natural history was another love. She nurtured the museums of natural history

like a mother. Today, museums of natural history have become institutions in their own right. This too, in no small measure was Grace's contribution.

She also dreamed of a major museum of war and peace, of implements, armoury and weaponry, and perhaps this will also become a reality.

Grace was moved beyond words when she received the Padma Bhushan award in 1982. She wrote, 'The Home Ministry has asked me to provide particulars. You really think that these details are required? Do I deserve it?'

Grace had another accomplishment for which many Indian and Asian scholars are indebted to her. She was a meticulous and thorough editor, who took pains to peruse the writings of many art historians. Her keen eye identified every turn of phrase, each punctuation mark, and proofreading error. She was always able to retain the flavour of the original style.

Above all, Grace was a full human being, generous and civilized, who identified herself with the complexities of this large continent and its plural cultures. She felt intensely and sincerely about causes and was deeply committed to the wealth of Asian materials. One may not be a believer in rebirth, but in her case it really did seem that perhaps in some previous birth she belonged to this part of the world. Spiritually and emotionally, she was Indian and Asian in a manner that can have little rational explanation. It was no accident that she had chosen to make India her home beyond the call of her vocation.

On 10 January 1985 Professor Morley was to be honoured by the Museum of Modern Art, San Francisco for her 50 years of association with that institution. But her doctors in India advised her not to travel all the way to America due to her frail health. It was indeed a pity that she could not go because the museum had planned a really elaborate celebration for her. There were to be 15 days of exhibitions, seminars and other cultural events. Grace Morley was herself to deliver three lectures to audiences of art connoisseurs. Yet on hearing that such a big show was being organized for her, she remarked with characteristic humility, 'I don't know why they are making so much fuss about me.'

In January 1984 Grace visited Kolkata and delivered an unforgettable address on Museums and Environmental Education. Soon after a brief illness, she left us at the age of 84. Friends from all over the world, her international family, mourned her passing. Appropriately, her friends decided to cremate her and to immerse the ashes in the water of the Ganga. Museum directors, art historians, scholars—all paid homage to the urn in that house of art: Bharat Kala Bhavan, Varanasi, before the ashes were immersed midstream. This was but right for Varanasi had been home to her in more ways than one. Here she had shared her deepest thoughts with the founder of the Bharat Kala Bhavan, that great scholar savant Rai Krishnadasa, whose ashes had been immersed in the same timeless river.

KAPILA VATSYAYAN

PREFACE

~

A picture book on sculpture, the technical resources of contemporary photography notwithstanding, suffers inevitably from its being confined to a flat surface. The textures and colours of the materials, captured as accurately as the modern camera and skill in lighting permit, compensate only to a limited degree for the missing dimension. The essential quality of sculpture, whether in the full round in monumental or more modest scale, or in the high or low relief of friezes and tablets of different periods and styles, lies in its plastic form, which can only be suggested in photographs and illustrations.

The justification for the present effort, which reproduces selected examples of Indian sculpture, is the importance that the art of carving, modelling and casting has held in Indian civilization for more than 4000 years. India provides today the best example of a cultural continuity that

has survived a long and diversified history, in which changes have occurred, old images of life have been altered and new elements and influences have been absorbed, enriching and variegating the cultural strands, without, however, breaking them.

Throughout the centuries, sculpture in India has been a dominant expression of the people and their land. Even though the nation has made noteworthy attempts to adapt itself to the modern world the majority of the population still lives in villages. Mainly agriculturists, they still follow ancient patterns of culture, including devotion to images representing the visual and tangible aspects of religion. Sculptors continue to fashion these images which still serve the majority of the people in temples, in processions for religious festivals, in shrines, in their homes and, likewise, in the humble form of terracotta as votive offerings as well as playthings.

11

This picture book is a survey, based on texts of archaeologists and art historians as well as a personal response to sculptural masterpieces, especially those in museums. It makes no claim to fresh discovery. It is intended simply as a handbook for visitors such as a museum might print on its collections to call attention to certain outstanding works representing different periods and localities and, therefore, styles. It is an effort at popularization, in the good sense of making known widely, Indian sculpture of quality. Its purpose is sharing admiration and enjoyment by agreeable illustrations, providing general information regarding background and subject matter, and highlighting significant details through brief comments.

The majority of the masterpieces here are works inspired by religion and have been selected for quality. Though deprived of their original setting of a temple or shrine, most being on exhibition in museums, they can be examined closely and appreciated primarily as works of art. For those who are not of the faiths represented, it is the quality of the artist's realization of the established image that is a sure guide to understanding and appreciation. For those whose beliefs the sculptures interpret the emphasis on quality, which

they likewise represent, has probably no essential significance. Yet here is the proof that the artists who created them, according to clearly defined rules, in the accepted idioms of a period, a place and its style, devoted their creative talents, to realizing the figures and symbols according to the highest standards of which they were capable. That effort at perfection was initially an act of worship. This book attempts to capture that perfection, as well as India's cultural continuity in stone, metal, wood and terracotta that 4000 years of sculpture in India represent.

I would like to thank those museums whose members cooperated generously with the publisher in facilitating photography for the book. Credits appear in the captions. The National Museum, New Delhi, the Indian Museum, Kolkata the State Museum, Lucknow, the Archaeological Museum, Mathura, and the Archaeological Survey of India's site museums, at Khajuraho, Sarnath and Varanasi, merit individual mention. The Archaeological Survey likewise assisted in photographing some monuments in its charge.

Finally, it is a pleasure to record here the appreciation of the publisher's patience in striving for the excellence desired by all concerned.

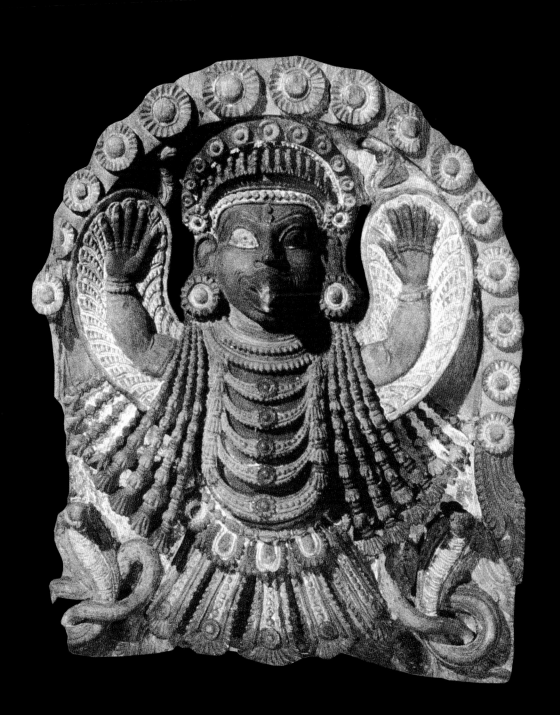

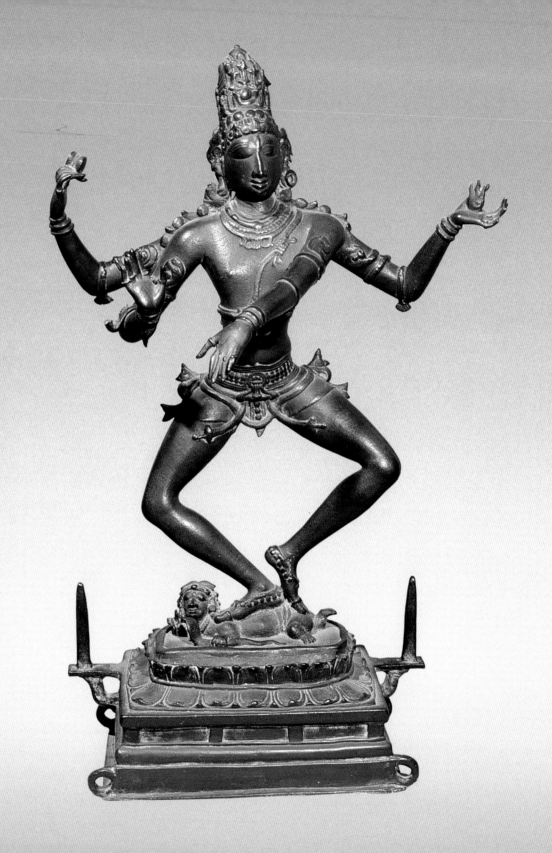

INTRODUCTION

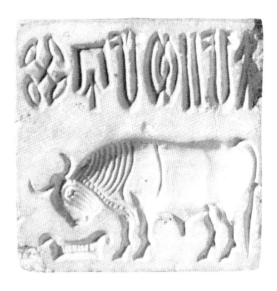

India has maintained cultural continuity for more than two thousand years. Natural calamities, internecine wars, foreign invasions and conquests, including long occupations by alien rulers, have disrupted or even destroyed other ancient cultures. The inhabitants of India have faced such events without loss of identity. In some instances indeed they have reacted with vigour and even benefited from them. This continuity, never static which remained deeply rooted in its origins despite changes, is nowhere more clearly demonstrated than in the uninterrupted evolution of the art of sculpture in India.

Some stone sculptures, fragments and perhaps a large figure or two, can be dated to the Mauryan period, which began with the rule of Chandragupta Maurya around 322 BC. From this time it can be said that the history of India began. Not only do inscriptions survive, but an account of the Mauryan Empire and of its capital Pataliputra, near modern Patna, was written by the Greek ambassador to Chandragupta's court, Megasthenes, and had wide currency in the ancient world. He represented Seleucus Nicator, a general of Alexander of Macedonia, left behind to govern a portion of the invader's conquest.

The first monumental sculpture of India was commissioned by Chandragupta Maurya's grandson, Ashoka (c. 272–232 BC), to crown with animal capitals the pillars inscribed with his edicts.

It must not be overlooked, however, that long before Ashoka ruled over his great empire an ancient, highly developed urban civilization, had emerged on the subcontinent. This was the Harappan or Indus Valley culture, named after the first site discovered, or after the mighty river on which stood its great city, Mohenjodaro. This city, like others of the culture, was constructed of baked bricks; had paved streets laid out in an orderly fashion, wells and drainage systems. It was defended

by a fortified citadel dominating the quarters of houses and shops. Contemporary with civilizations in Egypt and Mesopotamia, the Indus Valley culture flourished for approximately a thousand years, (c. 2500–1500 BC), and then disappeared and was forgotten until the discovery of its ruins at Harappa in 1921. Mohenjodaro is the largest city yet discovered but smaller settlements were distributed over a large area, stretching for some twelve hundred kilometres at least, from Harappa in the north to Lothal (Gujarat) in the south.

No monumental sculptures or architectural decorations belonging to this culture have been found, though a few small stone sculptures of heads and torsos and still smaller bronze castings of figures and animals have been discovered. The exceptional skill of the sculptors is evident in the exquisitely carved steatite seals bearing the likeness of bulls and other animals. Other examples are the figurines bearing symbols that are yet to be deciphered.

Archaeological evidence fails to explain the decline of the Indus Valley culture. For about a thousand years after it, until the Mauryan dynasty came to power, no civilization of equivalent attainment appeared on the subcontinent. Evidence of

settlements, of movements of populations, of patterns of culture during this long period, is still being documented as scientific excavations continue.

During this time the Aryans established their religious and cultural influence in northern India. Whether the Aryans were invaders or their civilization was an indigenous development is still not clear. It was long supposed that they came from the north and that they were part of migrating groups which also entered Europe, and where most modern European languages seem to derive from the same Indo-European source as Sanskrit. In any case, though not documented by archaeology as yet, and their origin still a mystery, the influence of the Aryans on the subcontinent was deep and lasting. They had an oral literature, preserved by an elaborate system of memorizing, of which the *Rig Veda*, a collection of hymns, is the most ancient, the most sacred and the most important part. Their language evolved into Sanskrit, the classical language of ancient India, and still that of the Hindu religion. The Aryans had a highly organized society, ruled by a warrior class and served by priests, whose knowledge of the

sacred oral literature and of rituals and ceremonies, as well as of sacrifices, which ensured the well-being of the people and made them powerful.

Midway during this period occurred two events destined to have a deep influence on human history. The leaders of two movements, which were to become important religions, were born to the rulers of small states in north India. They were Siddhartha of the Sakyas, who became the Buddha (*c.* 624–544 BC), and established Buddhism and Vardhamana of the Jhatikas, the Mahavira (Great Hero) (*c.* 599–527 BC), who established the Jain religion. Both of them renounced their aristocratic way of life to attain spiritual 'Enlightenment' by the practice of austerities. Both became teachers. They advocated high principles of conduct to their followers and gained devoted disciples to whom they preached, teaching them disciplines which

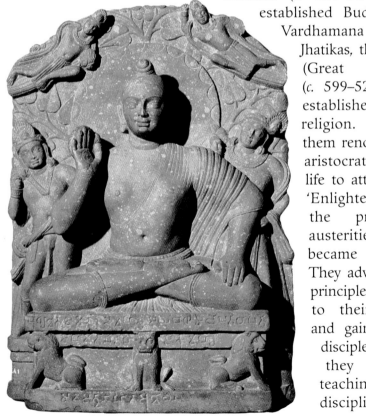

would lead to eventual release from cycles of rebirth. During their own lives they won large followings in north India. Both religions spread, in course of time, to other parts of the subcontinent as well. Eventually Buddhism was to be carried to Central Asia and thence to extend eastward to China, Korea and Japan. To win to the faith the ruler of Ceylon (modern Sri Lanka) and his subjects, Ashoka sent a relative there with a cutting of the Bodhi tree under which the Buddha had attained 'Enlightenment'. From Ceylon Buddhism eventually reached South East Asia, and it is the dominant religion of many countries in that region today. By contrast Jainism did not spread beyond India, but has remained an important minority religion up to the present. Buddhism ultimately declined in India and was absorbed into Hinduism, but elsewhere it evolved into different forms, including the distinctive Mahayana devotion practised in Tibet, Bhutan and Mongolia under reincarnated lamas, and Zen, familiar to the West as a Buddhist sect of Japan.

This long period, from the Indus Valley civilization to the Mauryan Empire, offers almost nothing in sculpture. Unique so far is the group of four bronzes—a chariot with its

driver, a bull, an elephant and a rhinoceros—excavated at Dhaimabad, Maharashtra, by the Archaeological Survey of India, now exhibited in the Chhatrapati Shivaji Museum, Mumbai. They are not sophisticated castings, but have the vigour of folk art. They are attributed to late Indus Valley influence and are thought to date (*c*. 1200 BC). Otherwise, only terracotta figurines, mostly female, some elaborately coiffured and bejewelled and of considerable elegance, but most crude, with features pinched or appliqued, and roughly modelled or cast bodies, probably dating from the sixth or fifth centuries BC, or later, represent the plastic art of this period. It is against this background of small-scale figures that the monumental inscribed pillars of Ashoka, crowned with animal capitals, appear as dramatic innovations.

The predominant medium of creative expression in the sub-continent, since the days of Ashoka, seems to have been sculpture. Or it may be that substances commonly used for sculpture, stone, terracotta and metals, being relatively durable, have survived in climates destructive to more fragile materials. This undoubtedly accounts, to a considerable extent, for the amount of ancient sculpture preserved. However,

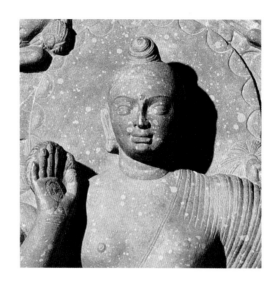

from the beginning of the present era, the production of sculpture increased steadily in India, resulting in a great quantity and variety of pieces principally inspired by the religions of India, as images for worship, or to illustrate episodes associated with them, or to adorn their settings. Certain centres stand out for the quality as well as for the quantity of this production.

Mathura was exceptional in the long span of time during which its sculpture maintained pre-eminence. Its terracottas include outstanding examples from possibly as early as the seventh or sixth century BC, and notable works of art in the Gupta period of the fourth through the sixth century. Its sculpture in stone likewise held a place of distinction from the time of the Kushan rule of the second

century of this era through the reign of the Guptas and continued to do so until at least the twelfth century. In the Gupta period, the red sandstone images of the Buddha, wearing the characteristic Mathura transparent pleated garment falling from both shoulders, were exported to other Buddhist centres in the subcontinent.

In south India, the Pallava dynasty, dominant from about the fourth to the tenth centuries was generous in providing patronage to the sculptors. They were commissioned to hew from granite hills, cliffs and boulders, a variety of works of art of outstanding originality and quality, at many places in the kingdom, but the most outstanding ones at Mahabalipuram. By the eighth century, the Pallava kings began to erect structural temples at Kanci, modern Kanchipuram, their capital, and in other locations in the kingdom. The Chola dynasty, conquerors of Pallavas and their successor in south India, continued to have sculptures carved in the granite of the region. Their outstanding achievement is, however, their commissioning of processional religious images in copper unsurpassed in their expressiveness and quality as art as well as objects of worship and ritual.

In the eastern part of the subcontinent, the Kalinga of Ashoka's period, the Orissa of today, an uninterrupted tradition of temple building in stone, embellished with sculptured bas-reliefs, decorative ornamentation and free-standing divinities, flourished from the eighth to the thirteenth centuries. Elsewhere in India temple building and decoration with sculpture went on vigorously for longer or shorter periods, depending on local circumstances. Eminence frequently reflected political power and enlightened patronage.

Throughout history sculpture has played an important role in Indian society, serving both religious and secular requirements such as the ornamentation of items of luxury as well as objects of daily use. These latter examples are rare, for articles used casually tend to become damaged, to wear out and then to be discarded. However, a sufficient number survives to illustrate the decorative inventiveness and skill of hand of the artisans who fashioned them.

The contribution of sculpture to architecture must likewise be emphasized. Rock-cut cave temples, and dwellings for those attached to them, date at least from Ashoka's time. Cave temples and monasteries, like Ajanta, Elephanta and Ellora, and many more examples found in other

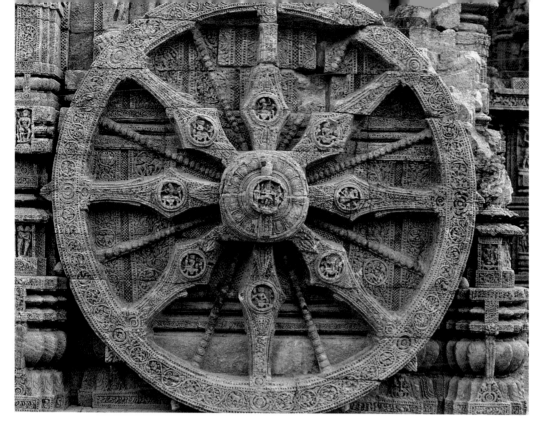

parts of the country, are famous. But it is the Kailasha Temple of Ellora, hewn complete from a stone cliff, that stands out as the culminating achievement of sculptors, who were also architects.

From about the eighth century, structural temples in stone began to be built in increasing numbers everywhere. In them, images were installed for worship, but sculpture was used also for decoration, within the temple, or only on the exterior, as prescribed by local custom. In later periods, such temples as those of Khajuraho of the eleventh century, Somnathpur and Konarak of the thirteenth century, had exteriors richly decorated with dancers, musicians, elephants and other animals in procession and human figures in every conceivable occupation and pose.

Earlier, less durable materials, especially wood, must have been used for building. Large structures, several storeys high, with projecting balconies, are depicted in early relief carvings. Ashoka's own palace at Pataliputra, described as magnificent by Megasthenes, was built largely of wood as has been confirmed by archaeological evidence.

The tradition of carpentry is revealed in the stone railings around the stupas, the commemorative

mounds, which are the most ancient monuments extant in India. The stone railings, defining the circumambulatory path, were put together like wooden fences, with upright posts, joined by cross-bars fitted into sockets.

Wooden structures of these earlier periods before stone and brick were used for temples may have had

abundance of sculptures in stone and metal.

Ashoka's capitals, however, firmly launched the tradition of stone sculpture in India. The Emperor intended them to attract public attention to his edicts, in which he laid down principles of government and exhorted his officers and subjects to observe high standards of morality.

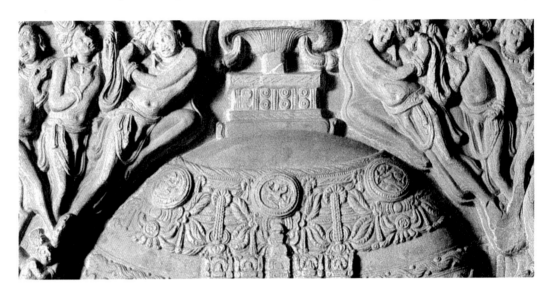

carvings. Were images for worship carved in wood? There are no clear references in Vedic literature to any images of the powerful and immanent gods to whom the Aryans addressed prayers and praise. Yet these divinities were to be the source of the Hindu pantheon, which in ensuing centuries was to be represented in such a diversity of forms, requiring an

The capitals and lofty inscribed pillars undoubtedly fulfilled his aims. They must have been impressive, serving, one might claim, as noble standards of the faith he supported. At the same time, the capitals, as they are exhibited at the Sarnath and Indian Museums, are splendid sculptures, simplified and stylized to some degree as appropriate to their function, but powerful and

majestic in the highly polished stone characteristic of the Mauryan technique.

These capitals are also the earliest Buddhist sculptures. Of the three great religions originating in India, all three calling on sculpture to give visual form to the objects of their devotion, it is Buddhism which inspired the first sculptural works of

Of the first few centuries following Ashoka, the monuments that survive are few, and for each period one must use, in a general way, what remains to trace the evolution of sculpture. Thus the Sunga period of the second century BC is best represented by the single gate and portions of the railing of the Bharhut stupa from

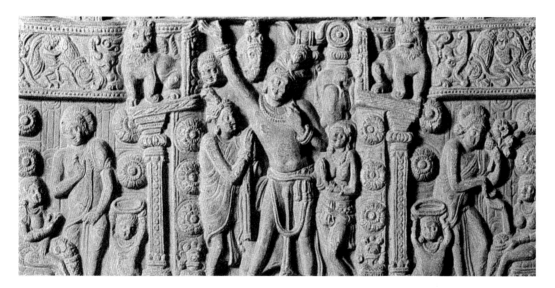

art. There resulted a vast production, first of narrative bas-reliefs, then of images of the Buddha and, later, of the Bodhisattvas. The story of the Buddha's own life and the Jataka tales—episodes of his former lives—provided attractive subject matter and ample opportunity to the sculptors to depict contemporary life based on observation as well as the chance for

central India, exhibited in the Indian Museum, Kolkata. The posts of the gate are decorated with standing figures and the crossbars of the railing and the coping have sculptures of bears and medallions of heads on them. The coping also has other animals and trailing vines sculpted on it. A somewhat archaic awkwardness about the figures, and the striking

design of the medallions appeal strongly to contemporary taste. Fragments of stupa railings and other contemporary carvings from sites in north India indicate that the Bharhut sculptures were not unique in their time.

Three sites distinctively represent the sculpture of the next few centuries: Sanchi, Amaravati and Nagarjunakonda. At Sanchi, which is the earliest (third century BC to the first century AD), are preserved the stupa, the railings on both levels without sculptures, and the richly sculptured gates, at the four cardinal points. Sanchi, therefore, has special value as an illustration of the typical stupa. The gates, erected probably late in the first century BC, have three architraves, which, with the posts, are intricately carved with scenes from the Buddha's life and from the Jataka tales, together with decorative animals and figures, on both the front and back. The bracket figures of the Yakshis, female tree deities, graceful in what seem dance poses, conform to the convention of the ideal female figure of large rounded breasts, a slender waist and ample hips. The gates are believed to be donations by the faithful. An inscription which identifies the sculptors as local ivory carvers seems plausible if the detail, the refinement and the meticulous finish of the carvings are considered. One marvels at the artisans who had not only the imagination but the consummate ability to apply their skill successfully on a much larger scale and to a material very different from what they usually employed.

Amaravati, of the second century BC to the third century AD, and Nagarjunakonda, of the second and third centuries AD, on the Krishna River, represent Buddhist penetration into south India and are especially notable for their sculpture. By contrast with the north, where Buddhism was firmly rooted, it had less impact in the south and fewer centres developed.

Amaravati and Nagarjunakonda had stupas of a distinctive type considered peculiar to the south. The principal distinguishing feature was a platform on each of the four sides on which stood five pillars. The stupas of Amaravati and many stupas of Nagarjunakonda had slabs on which was sculptured the likeness of the stupa itself.

The great stupa at Amaravati had collapsed when the site was first discovered in 1797. Already settlers in the newly founded town nearby were pillaging the remains for building material. Fortunately, the sculptured marble casing slabs and the sculptured railing, which in the early

nineteenth century had begun to be burnt to produce lime, were rescued and the remains are now in the British Museum, London and the Government Museum, Chennai. At Nagarjunakonda, the foundations of stupas, of monasteries and of other buildings discovered were re-erected on a hill, which later became an island, when the valley was submerged to form a vast reservoir.

Meanwhile, in north India, Buddhist shrines and monasteries multiplied under the Kushans in the first and second centuries AD. Their conquests extended from Afghanistan to Mathura, some 140 kilometres south of modern New Delhi. Centres notable for sculpture were Mathura in the south and Gandhara, included in what is now Pakistan's North-West Frontier Province, with its capital at Peshawar. Gandhara produced, principally in the black schist of the region, narrative sculptures of the Buddha's life and of the Jataka tales on stone friezes to decorate stupas of different sizes. Then, somewhat later, images of the Buddha and of the Bodhisattvas were fashioned. The Bodhisattvas in the likeness of princes are of great elegance, following conventions of the figure, of the features, of jewellery, of drapery and of decorative motifs derived from contemporary Mediterranean,

Hellenistic or Roman sources.

Mathura employed red sandstone, or red sandstone speckled with buff, characteristic of the locality. The images and the themes were inspired by Buddhism, but during the Kushan period, in contrast to the grace and elegance which characterized the Gandhara style, here was retained some of the forthright frontal treatment and awkwardness found earlier in the Bharhut sculptures of the Sunga period.

There was some exchange of sculptural traditions between the two dominant centres of the Kushan rule. The convention of the pleats of the Buddha's transparent upper garment, covering both shoulders and falling almost to the ankles, usual at both centres, is an example. This continued to be the characteristic garment of the Buddha in Mathura during the reign of the Guptas as well.

The Empire ruled over by the Gupta dynasty, from the

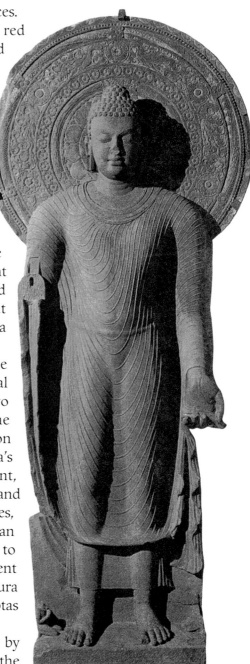

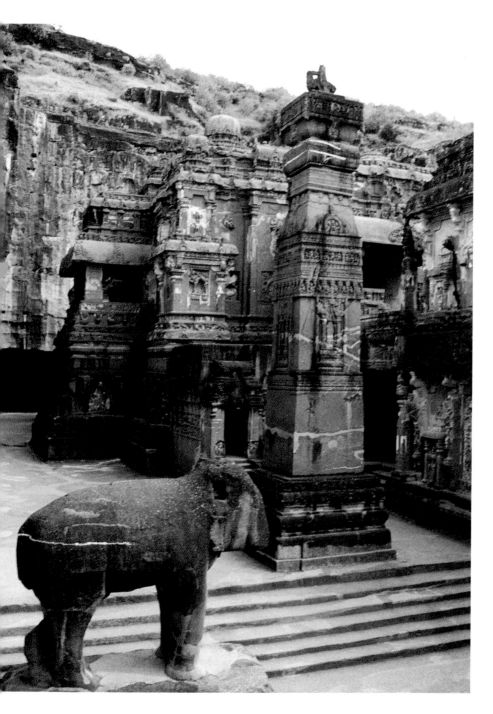

fourth to the seventh centuries, at its height nearly equalled in extent that of Ashoka, and its influence extended beyond its own borders. This period has been generally considered a time of outstanding achievement in learning, in culture and in the arts, and is often referred to as India's 'classic' period. Mathura continued to be a major centre for sculpture, and the characteristic red sandstone was widely used for narrative reliefs to decorate shrines. It is, however, the Buddha image with the halo, seated, but especially standing, that is seen as Mathura's great contribution at this time. It has become an image to worship, an expression of perfection. It offers no great opportunity for creative invention. The Buddha's expression is serene, with downcast or half-closed eyes, to emphasize meditation and inward vision. The halo is composed of concentric bands of stylized vegetation and of abstract decorative patterns, against which the head is centred. There is little difference from statue to statue, despite some range in size. The characteristic pleated garment is also characteristic of this style. In the rosy sandstone of Mathura, the image is of great refinement. It exemplifies complete assurance in technique, and it seems the perfect embodiment of the type. But there were other centres

in north India, where Buddhist sculptures of excellence were produced during the Gupta period, though somewhat different conventions were followed. For example, elsewhere in north India the upper garment normally covered both shoulders and was equally transparent, but fell straight, without the folds. Sarnath and Nalanda were especially important centres at this period.

Rock-cut temples and cells for monks also date from the Gupta period, and they continued to be hewn out of stone hills and cliffs for several centuries in different parts of the country. An example is the Buddhist group of thirty rock-cut shrines and monks' cells at Ajanta. Some were begun earlier, but twenty-three were added by the Vakatakas from about AD 450. Ajanta is known and admired principally because of the fine mural painting surviving in several of the caves, but the sculpture, both within a number of the caves and on several facades, deserves attention and reaches the same standard of excellence generally prevailing here.

As the Gupta period advanced, the two other religions, those of the Jains and the Hindus, became increasingly influential and steadily gained adherents. The result was the founding of places of worship by both faiths, requiring images for worship and sculptural embellishment. The technical excellence and the refined style were a common heritage.

Elephanta, an island in Mumbai harbour, is an outstanding example of a cave temple. It dates probably from the early seventh century. It was a shrine dedicated to Shiva and had numerous sculptures but many suffered damage from early European abuse. However, the Shiva head of three faces, the Mahesa-murti, remains intact and is to be recognized as a great sculptural masterpiece.

Ellora is in the same region as Ajanta. The earliest group of Buddhist shrines and monks' cells date from about AD 400 through the seventh century. The final group of five was dedicated to Jainism and dates from the ninth and tenth centuries. In between are the shrines, from the seventh to the ninth centuries, excavated under the Chalukyas and the Rashtrakutas, who succeeded them. This latter dynasty is responsible for the Kailasha Temple, the eighth-century AD monolithic shrine of Shiva, a complete temple of two storeys, provided with all the required elements, carved out from a hill of stone, its exterior decorated lavishly with sculptures of elephants, horses, divinities and figures from the

epics. It undoubtedly ranks as a masterpiece of stone carving, the largest and finest of its type in India. It is a heroic conception in architecture as well as sculpture, and an outstanding achievement.

The prominence assumed at Ellora by the Hindu temples cut into the stone cliff may be recognized as reflecting a trend. By the end of the Gupta period Buddhism was no longer dominant, even in the north, where it had prevailed for so long.

After the Gupta period it was predominantly the Hindu faith which was to account for the proliferation of the structural temples which now began to be built everywhere in the country. If stone was not abundant, or economy a concern they were constructed of brick and decorated with terracotta figures and plaques of Hindu themes and deities and ornamental motifs. A surviving example is at Bhitargaon near Kanpur. The terracottas that have remained are now in the State Museum, Lucknow. The skill of the Gupta sculptors in terracotta has been demonstrated by archaeological remains from many sites. In this traditional humble material of baked clay, they excelled in modelling figures of great beauty, in all respects equal in aesthetic quality to the stone sculptures of the period. But for construction of temples and for sculpture for their adornment, stone was obviously preferred.

As kingdoms rose, succeeded one another in different parts of the country, and provided patronage, temples were built and were supplied with sculptures, within the shrine for worship, as also for decoration, inside the sanctum, or only on the entrance and exterior, depending on the period and the place. Variations in regional styles developed, each centre contributing to the enrichment of the prevailing style that all shared, thus providing a local accent.

From this time onward temples multiplied, dedicated primarily to the Hindu religion. Important centres for the Jains were also founded. Obviously, in a brief survey of the art of sculpture in India to do more than draw attention to exceptional examples is impossible. But in those representing peaks of excellence from one point of view or another, in different regions at different times, a general impression may be gained of the dimension and of the quality of a vast production.

It is pertinent to give some

attention here to the subject matter with which Indian sculptors were concerned. The Hindu religion offered to them a new and rich repertory of figures and themes, as well as a conception of form differing from that which the Buddhist faith had required.

The Buddha and his disciples and devotees represented in narrative friezes, on plaques, and by free-standing statues, had the normal human form. The Buddha, despite his super-human birth and the miraculous episodes of his life, was a human image. Even the sacred signs which indicated his exceptional role like the *urna*, a mark between the brows, and the *ushnisha*, the protuberance on his head, and other peculiarities, were not given undue prominence. The first was indicated often as a tuft of hair; the second was represented frequently as a sort of bun. The Buddha, seated or standing, was rendered as a static image representing serenity and repose, a sacred personification for reverence and worship.

By contrast, the Hindu divinities in general appear dynamic. They are often depicted in intense activity, like the dancing Shiva, the Nataraja (King of Dance), or like Durga slaying the Buffalo Demon, or even when relaxed, like the dancing Ganesha,

they convey a sense of movement. The conception of the multiple arms, whether the figure is in action or in repose, holding attributes symbolizing powers, implies activities. The various birds and animals, representing the vehicles of these deities, rendered so often along with them, likewise suggest mobility.

The number and variety of the sacred images, male and female, their attributes, and their diverse roles in different contexts, with all the background of a complex faith which they invoke, provided for a broad range of sculptural representations. Though the work was commissioned and was guided always by established conventions, the sculptors, taking full advantage of the opportunities open to them, constantly strove for vivid expressions within these limitations. An example is the dwarf figure symbolizing evil or ignorance, grasping a snake, under the right foot of the Nataraja. Always ugly and suffering visibly under the pressure of the dancing Shiva, the dwarf is represented with individuality and is given a diversity of recumbent attitudes and facial expressions. Even the snake has a personality.

The proportions of the Hindu

images, their attributes and poses were strictly prescribed by the sacred texts. The sculptor's creation of an image was an act of worship, prepared for and accompanied by ritual.

The Jain nude Tirthankara, by contrast, offered even less scope for variety in treatment than the Buddha, confined as the image was to the two static poses, seated in meditation or standing in austerity, its legs entwined by creepers and the anthill of legend beside the feet. Some variety was provided in time by associated symbols and attendant figures. Nonetheless, despite limitations, there are distinguished sculptures inspired by this faith. The most striking are the colossal monolithic statues at several sites in south India. The most ancient and tallest of the Bahubali statues is the standing Gommatesvara, 17.5 metres in height, carved from a granite on the crest of Indragiri hill at Sravana-Belagola, Karnataka, consecrated in 1981. At Karbal and Venur, near Mangalore, stand two more recently erected and consecrated images of Bahubali. In February 1982, a Bahubali monolith, 11.7 metres in height carved by sculptor Ranjaja Golapa Shenoy, was consecrated at Dharmasthala, Karnataka, about 75 kilometres east of Mangalore. The artist had earlier carved a Bahubali erected at Ferozabad.

To be noted also as a characteristic of Hindu sculpture are the sensitive contours, soft and rounded, and the absence of emphasis on bone and muscle. Then there are such exaggerations as those of the ideal female form. This is in contrast to the sculptural traditions of the West, derived from the Greek study of anatomy, resulting in emphasis on the firm structure of the body, even when creating an idealized divine or human form. It contrasts likewise with the later striving for realism of the Roman sculptor.

Hindu sculpture, therefore, represents a treatment of form distinct from that of the Western tradition. It must be understood and appreciated on its own terms. The multiple arms, and sometimes heads, which Western art connoisseurs of the nineteenth and early twentieth centuries found so disturbing, even revolting in some recorded instances, are no longer a barrier to the museum visitor of today. Exhibitions of Indian art have been frequently held in the West during the past decade. Moreover, in art circles everywhere, with the development of modern art movements and the search for new sensory experiences, aesthetic understanding and sensibility have greatly broadened and are no longer inhibited by the rigid classic

heritage from Greece and Rome entrenched so strongly in the Western understanding of art up to the twentieth century. Therefore, there is not only tolerance for the distinctive features of Indian art, its symbolism and its representation of a more than naturalistic world, but a sincere admiration for the successful devices that Indian artists conceived to make their meanings clear, especially when they transcend the bounds of purely physical reality. Obviously the complex nature of many images provides a range of solutions for sculptural problems, to be regarded as more or less successful according to the skill of the artist. Examples are the articulation of the multiple arms, awkward or adroit, as the case may be, the dexterity of fitting an image in action into a given limited space, the relation of image to image in a group and the disposition of details in a medallion or on a plaque. Satisfactory handling of such elements, often intractable as they seem, is a guide to the ability of the sculptor and to the quality of the work as art. Obviously the same concern for composition, intrinsic to any art, also governs the Indian sculptor. In general, the quality of design is high at all periods, no matter what demands iconography imposes. In some periods, the sculptor's skill, and presumably the patron's taste, in demanding richness of detail and ornamentation, leads to what by standards of today seems an over-abundance of decoration, tending to obscure the fundamental quality of the subject. Generally speaking, in India as elsewhere, virtuosity tends to be a late development. Again it is a matter of evaluating the work within its own context of period, place and style.

After the Gupta period, the most spectacular achievement in sculpture is contributed by the Pallavas in south India, in the seventh century. This can be seen, especially in Mahabalipuram, about 60 kilometres south of modern Chennai.

The Pallavas, the dominant power in south India from the fourth to the ninth centuries, had, by the seventh century built important Hindu temples at Kanci (modern Kanchipuram), their capital, and elsewhere in their territory. However, they are remembered and hold a unique position in the art of sculpture and in the architecture of India because of the remarkable complex of monuments in stone which they created at Mahabalipuram, believed to have been their seaport. This rocky area, with a hill and a cliff of solid stone, and many large boulders scattered about nearby, was turned, under royal patronage, into a variety

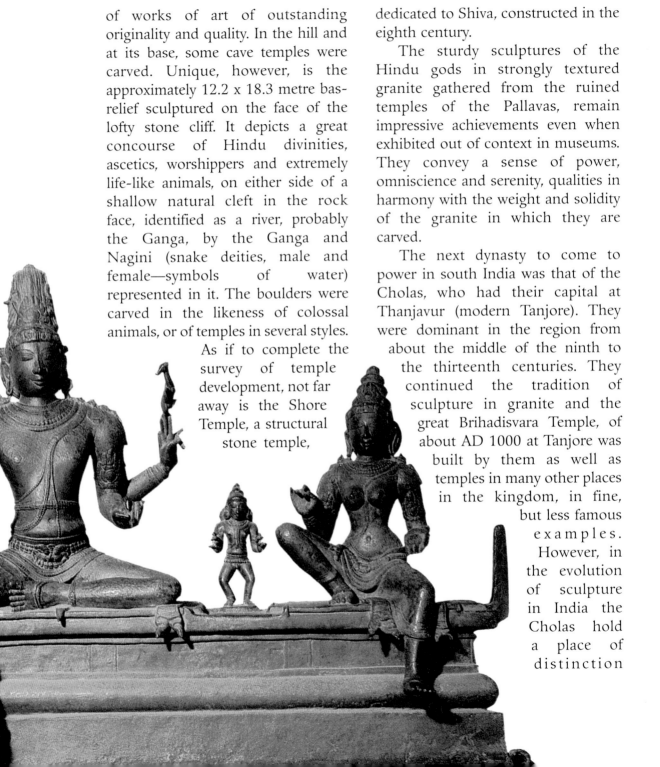

of works of art of outstanding originality and quality. In the hill and at its base, some cave temples were carved. Unique, however, is the approximately 12.2 x 18.3 metre bas-relief sculptured on the face of the lofty stone cliff. It depicts a great concourse of Hindu divinities, ascetics, worshippers and extremely life-like animals, on either side of a shallow natural cleft in the rock face, identified as a river, probably the Ganga, by the Ganga and Nagini (snake deities, male and female—symbols of water) represented in it. The boulders were carved in the likeness of colossal animals, or of temples in several styles. As if to complete the survey of temple development, not far away is the Shore Temple, a structural stone temple, dedicated to Shiva, constructed in the eighth century.

The sturdy sculptures of the Hindu gods in strongly textured granite gathered from the ruined temples of the Pallavas, remain impressive achievements even when exhibited out of context in museums. They convey a sense of power, omniscience and serenity, qualities in harmony with the weight and solidity of the granite in which they are carved.

The next dynasty to come to power in south India was that of the Cholas, who had their capital at Thanjavur (modern Tanjore). They were dominant in the region from about the middle of the ninth to the thirteenth centuries. They continued the tradition of sculpture in granite and the great Brihadisvara Temple, of about AD 1000 at Tanjore was built by them as well as temples in many other places in the kingdom, in fine, but less famous examples. However, in the evolution of sculpture in India the Cholas hold a place of distinction

because of the superb bronzes of the Hindu deities that were produced during their time. Used for subsidiary shrines in the temples, these images are intended especially to be carried in processions. They are single figures or groups of great elegance and refinement. The most famous is, of course, the dancing Shiva, called Nataraja (King of Dance), found in several poses.

The technique of the Chola sculptors is the well-known *cire perdue* (lost wax) process, in which the figure, in all its detail, is modelled in wax, then covered with a thick coating of several layers of clay. Heated, the clay forms a strong mould, while the wax runs out. It is then replaced by molten metal of varying compositions, but with copper as the major component. The most prized pieces are those of the tenth and eleventh centuries.

Sculpture in bronze was widely practised in India before the Cholas. The small figurine of a nude girl found at Mohenjodaro is evidence of the art's antiquity. Also there were bronzes of more than life size, proved by the unique surviving example, the Buddha from north India now in the Birmingham Museum thought to date from about the eighth century. Small bronze sculptures of deities were favoured for domestic shrines and are preserved in great quantities from all parts of the country, always interesting and sometimes very fine. But bronzes of folk and tribal styles also have been and continue to be made.

In all parts of the country, temple building now went on at a steady pace. In general, Hindu temples predominated everywhere, but in some parts of the country Jain places of worship received almost equal attention, and shared to a considerable degree the same stylistic developments, with suitable adaptations for differences of worship and ritual.

Aihole may be taken to mark the beginning of the evolution of the structural temple, finally to reach in this region its full flowering for sculpture in the ornate Hoysala style of the twelfth to thirteenth centuries. The star-shaped ground plan of the temples provided extensive wall surfaces for the ornate exteriors, while the interiors were lavishly sculptured as well. The most complete and perfect illustration surviving is Somnathpur near Mysore, dating from the middle of the thirteenth century. Around the eleventh century, under the Chalukyas and Hoysalas, as at Halebid (twelfth century) and in neighbouring kingdoms, Jain places of worship began to share with Hindu temples the ornate architectural style

of highly decorated exteriors and interiors, so that the austere nude images of the Tirthankaras in their separate cells gained richly sculptured settings. This tendency continued in the predominantly fifteenth century *bastis*, replacements of earlier shrines or additions to them, built as 'temple cities', on sacred hills, such as the famed Jain pilgrimage centres at Satrunjaya and at Girnar, in Kathiawar, and at Mount Abu in Rajasthan. The gleaming white marble favoured contributed to the delicacy of the sculptures, but, as time advanced, tended also towards a perfunctory ornamentation, skilful, but lacking in creative vigour.

Further north in central India, the Hindu and Jain temples of Khajuraho of the tenth to the twelfth centuries form the most famous temple complexes of the medieval period. They are decorated profusely with sculpture inside the sanctum and on the exterior. The human form has been handled with consummate skill and special grace.

In the north and east, in the present states of Bihar and West Bengal, the Buddhist heritage remained a living force until the destruction of Nalanda and other Buddhist centres late in the twelfth century; but vigorous, also, was the growth of Hindu temples during the Pala and Sena dynasties of the eighth to the twelfth centuries. They were decorated with sculptures principally in the black basalt of the region and were rich in decorative detail, but tended towards some rigidity of posture, in contrast to the relaxed poses and graceful styles of central India. Thus the images seem to embody dignity rather than charm, though the sculptors' virtuosity remain impressive.

To the east was the Kalinga conquered by Ashoka at so great a cost to human life and misery that in revulsion the Emperor converted to Buddhism. Thenceforth, the aim of his rule was only to strive for moral conquest as his edicts announce. Here Buddhism flourished as literary references and the remains of the great centre of Ratnagiri testify. But it is especially important for the brilliant period of uninterrupted construction of Hindu temples from the eighth century, thus representing a rare example of continuous development. It culminated in the great creative achievement of the Sun Temple at Konarak, in the thirteenth century. Even though partly ruined, this temple, conceived as the chariot of the Sun God, with twelve sculptured wheels and seven rearing horses, remains, in its adornment of the walls, in the colossal figures of

heavenly musicians surmounting the porch and of animals in action, a supreme achievement of creative imagination and of sculptural realization.

The tradition of sculpture in India, evolved through millennia, was so powerful that neither foreign conquest nor divergent religions imposed on parts of the country could suppress it. There were profound changes. From the thirteenth century, under Muslim dominance native builders and sculptors in stone contributed their skills to the construction of mosques, tombs and fortress-palaces, enriching them with calligraphy, inlaid patterns and tracings of stylized plant forms, as on the bases of the columns of the Red Fort, Delhi, and in the screens of the Mosque of Sidi Sa'id, Ahmedabad. Similarly, from the sixteenth century, the Portuguese colonies profited from the Indian builders' knowledge of construction and from the indigenous sculptors' transfer of their talents to their fashioning of images serving an imported faith—Christianity. The polychrome religious sculptures of Goa competed on equal terms with the sacred images of Brazil and of the Spanish colonies of the New World, while the delicate ivories on Christian themes of the Indian sculptors had no rivals and continued

an ancient traditional art in new forms.

However, in many parts of the country the building of Hindu and Jain places of worship and their requirements in sculpture, whether of images for worship, or suitable adornment, continued and still do so. There were exchanges of influences between East and West, which led to an additional enrichment of the tradition. Meanwhile, sculpture maintained its traditional role in folk and tribal arts and crafts, in the varied materials, often ephemeral, that the rural artist had at hand. Thus images in wood decorate temple processional cars, and also private houses; votive offerings, village deities and toys, carvers and modellers fashion in terracotta and metal; dance masks and ornamented objects for daily use employ, as always, carvers' and modellers' skills. As a living continuity creative expression in three dimensions has been transformed, but in these and in many other ways it still contributes to the enrichment of Indian life.

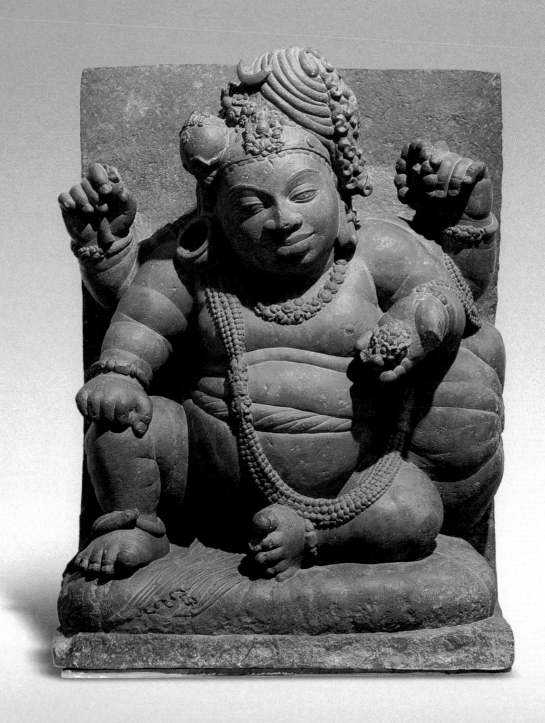

MASTERPIECES OF INDIAN SCULPTURE

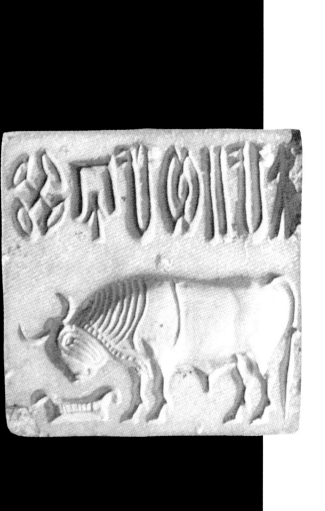

The Indus Valley Civilization

(LEFT) SEALING OF A BULL
(IMPRESSION OF THE ORIGINAL SEAL)
STEATITE, 3.5 CM X 3.5 CM

(FACING PAGE) DANCING GIRL
CAST COPPER, 14 CM (HEIGHT)

INDUS VALLEY, C. 2500-1500 BC
NATIONAL MUSEUM, NEW DELHI

The brick buildings, arranged in so orderly a fashion in well-laid out towns in the sites so far excavated in Pakistan and India had no sculptural decorations. At least none survive.

The small stone torsos, the terracotta figurines, including the wheeled cart and other toys and the cast metal animals reveal the artisans' competence. The cast copper figurine, called the Dancing Girl, from Mohenjodaro, by exception is expressive in its economy of form and may be considered the creation of an artist-modeller. It is the steatite seals, about 4 centimetres wide, with their exquisite intaglio carvings of animals, more rarely of figures, inscribed with the as yet undeciphered symbols, which testify to an acute observation and execution in small-scale sculpture by skilled artists.

What use the seals were put to is conjectural. Most have bosses on their backs allowing a cord to be passed through for the convenience of carrying and handling them. It has been suggested that, impressed on soft clay to make a 'sealing', they served to identify the shipper or to certify the quality and quantity of trade goods. It has been reported that a few sacks of products thus sealed, accidentally burned and the clay impression was baked hard, thus supporting this hypothesis. A few Indus Valley seals found in Mesopotamian sites originally contributed to the tentative dating of the Indus Valley culture.

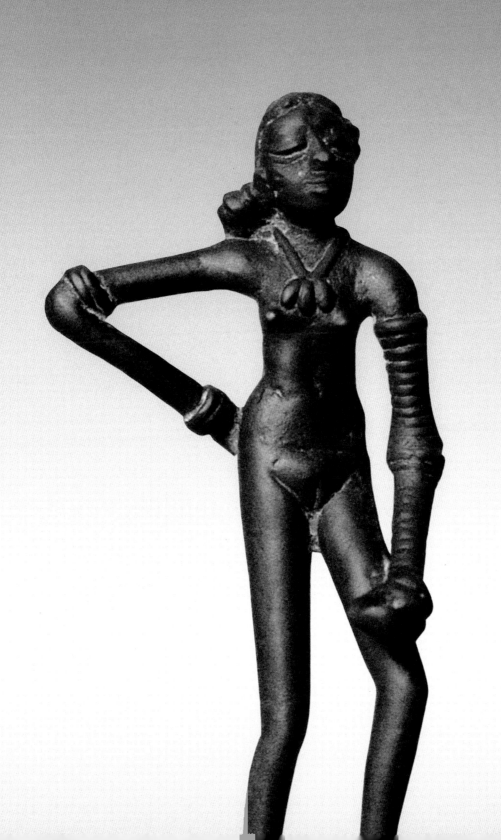

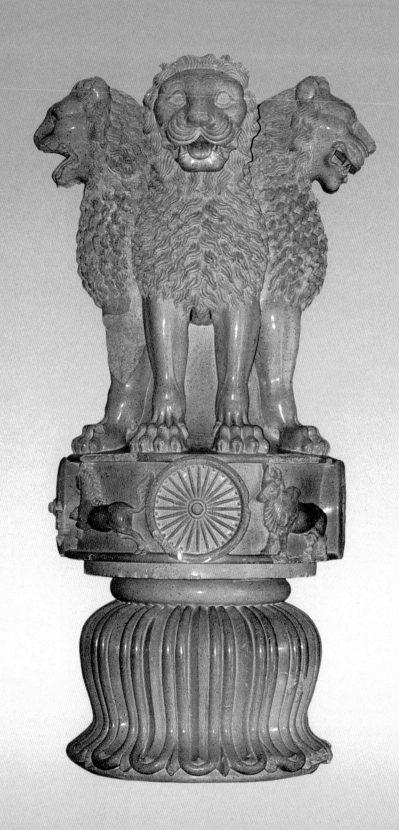

The Lion Capital

MAURYAN, THIRD CENTURY BC
CHUNAR SANDSTONE, HEIGHT 215 CM
SARNATH, UTTAR PRADESH
ARCHAEOLOGICAL MUSEUM, SARNATH

Buddhism must be credited with playing a major role in the long and vigorous tradition of sculpture in the subcontinent. Small-scale sculptures, in stone, bronze and terracotta, remain from the Indus Valley civilization. Terracotta figurines in different styles are known from possibly the eighth century BC. But only with the Mauryan Emperor Ashoka's patronage and the demand for narrative and decorative sculpture for stupas and their railings and gates, from the Sunga period of the second century BC, does sculpture develop without interruption. The carved stone capitals of the pillars, inscribed with the edicts of the Mauryan Emperor Ashoka (third century BC) represent the earliest works of monumental sculpture in the subcontinent.

The Lion Capital with the four lions, back to back, found at Sarnath near Varanasi, where the Buddha preached his First Sermon in the Deer Park, is the most famous capital. It has been adopted by the Republic of India as its national emblem. The lions originally supported the Wheel of Law, the symbol of the Sermon.

The tan sandstone quarried at Chunar, near Varanasi, is highly polished, and glistens like metal, a characteristic of the sculptural technique of the Mauryan period.

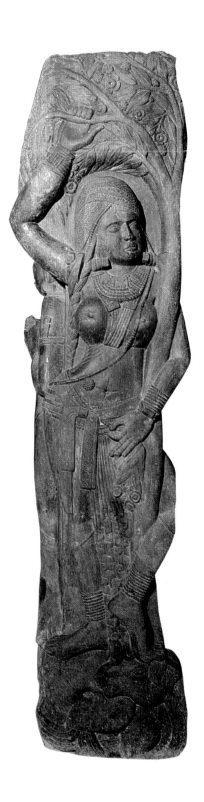

Yakshi

SUNGA, SECOND CENTURY BC, RED SANDSTONE, HEIGHT 250 CM
BHARHUT, MADHYA PRADESH, INDIAN MUSEUM, CALCUTTA

The portions of the railing and the single gate preserved from the Bharhut stupa are lavishly carved. Figures and subjects represented are frequently labelled so that they provide helpful identification of scenes from the life of the Buddha and from the Jataka tales.

This Yakshi is carved on a post of the railing and is represented as grasping a branch of a tree above her head and with one leg around its trunk, thus emphasizing her role as a tree deity. She stands in a dance pose on an elephant. The sculptor's understanding and skill are evident in the rendering of the form of the animal.

The Yakshi wears a profusion of jewellery and a diaphanous pleated lower garment, held in place by a beaded belt and a knotted sash. She embodies the ideal of the Indian female form with large breasts, a slender waist and ample hips. The image has a certain archaic awkwardness of pose, of great appeal and decorative effect.

Yaksha

SATAVAHANA, SECOND CENTURY BC, GREY SANDSTONE, HEIGHT 88 CM
PITALKHORA, UTTAR PRADESH, NATIONAL MUSEUM, NEW DELHI

This portrayal, plump and sturdy, with its wide smile and expression of merriment, has the essential characteristics of the few bulky Yaksha figures, generally attributed to the first century AD. Yet it is more delicately sculpted than is usual for such figures. Indeed, Yaksha figures are often relatively crude. They are considered nature divinities, and in their heroic stature and boldly sculpted forms, they seem to represent the power of nature.

This Yaksha of Pitalkhora, on a much smaller scale, appears both more genial and more gracious, and very much less remote. The face fortunately has suffered no damage, but the left arm from the elbow, and the hand, are missing. Like the right, the left hand probably touched the crown. On the back of the raised right hand is an inscription identifying the carver as a goldsmith.

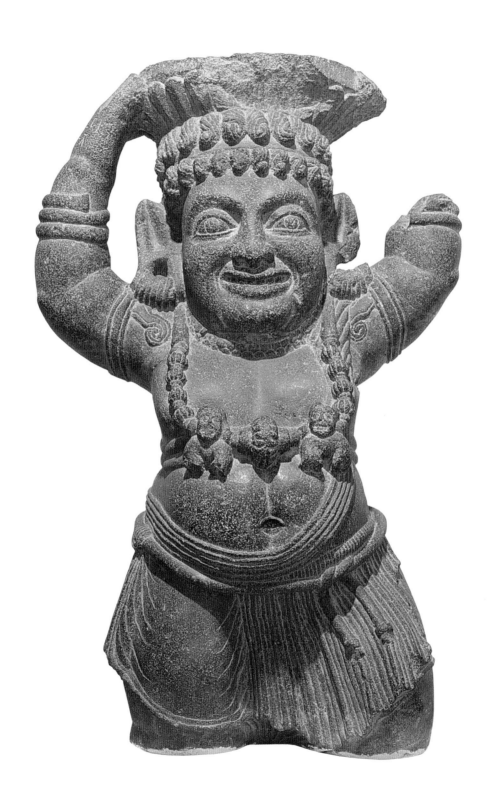

The Great Stupa at Sanchi

EARLY FIRST CENTURY BC
DIAMETER OVER 36 M, HEIGHT 16.46 M
ENLARGED STUPA , SANCHI
SANCHI, MADHYA PRADESH, ADMINISTERED BY THE ARCHAEOLOGICAL SOCIETY OF INDIA

The Great Stupa at Sanchi is of particular significance as it typifies the early stupa form of north India. The original stupa, attributed to Ashoka, was about half the size of this surviving structure. About a century later it was enlarged to its present dimensions and received a stone casing. A terrace was added to form a processional path, reached by a double flight of steps to the platform on the southern side.

The stone of the stupa was covered with plaster and painted. At its top it had a square railing, from which rose triple umbrellas. On the ground level also there was the usual processional path as clockwise circumambulation was the prescribed form of reverence. The massive railing of stone posts and cross-bars, clearly reproduces a wooden fence. This railing bears no sculptures and in this respect differs from that of Bharhut, dated about a century earlier. The intricately carved gates are a great contrast to this unadorned massive railing.

The stupa, as an indispensable symbol of devotion to the Buddha, accompanied the religion as it spread throughout Asia, taking different forms according to the place and period.

44

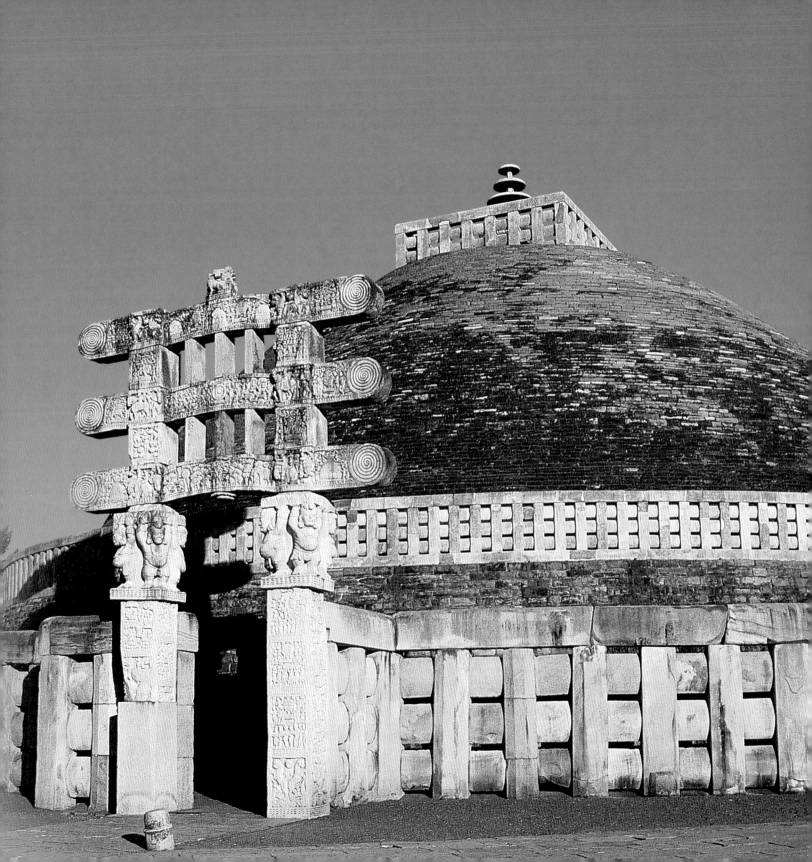

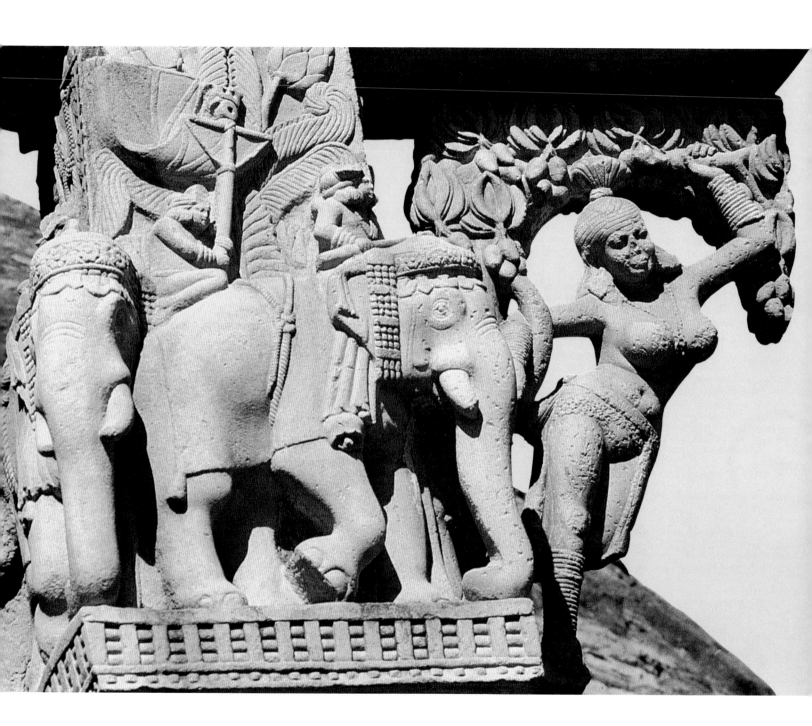

Sanchi: The Sculptured Gates

YAKSHI BRACKET FIGURE, WITH ELEPHANTS
GATE HEIGHT OVER 10 M
NORTH GATE, GREAT STUPA, SANCHI (DETAIL)
SANCHI, MADHYA PRADESH, ADMINISTERED BY THE ARCHAEOLOGICAL SURVEY OF INDIA

The elaborately sculpted gates of the Great Stupa of Sanchi are considered to date from the late first century BC and early first century AD. There are four gates, facing each of the cardinal directions. They are thought to have been carved and installed over a considerable period, possibly about fifty years.

In contrast to what the surviving gate of Bharhut represents of sculpture on a somewhat large scale, the Sanchi gates employ sculpture of a delicate type and introduce a great deal of decorative as well as narrative detail, on both the front and the back. An inscription on the south gateway states that it was fashioned by the ivory carvers of Videsa (modern Besnagar), about eight kilometres from Sanchi, known to have been a well populated centre at the time. One marvels at the skill of the carvers who were able to apply the techniques they used ordinarily on ivory, to stone.

The subjects depicted are principally the Jataka tales, episodes from the former lives of the Buddha, the edifying stories that he used when he preached to illustrate some specific recommendation to his followers.

The form of the gates is the same as that of Bharhut: two upright posts joined at their top by an architrave, consisting of three lintels. Called *toranas*, these gateways became usual features of the entrances to the railing defining the processional path around the stupas of north India.

The Sanchi gates are lavishly carved. A Yakshi (tree spirit) wearing a transparent skirt, jewellery on her ears, wrists and ankles, strikes a graceful pose, suggesting that she is dancing, as depicted in the bracket here.

The Prophecy of the Sage Asita

SATAVAHANA, SECOND CENTURY AD

PALE BUFF LIMESTONE, DETAIL 188 X 87 CM

AMARAVATI, ANDHRA PRADESH

NATIONAL MUSEUM, NEW DELHI, LOAN BY THE TRUSTEES OF THE NATIONAL MUSEUM, LONDON

Soon after the birth of Prince Siddhartha, the future Buddha, the ancient sage Asita came from his mountain abode to the palace of Suddhodana, the Sakya chieftain and Prince Siddhartha's father. He reported that there was rejoicing among the gods because 'a great man' had been born and he asked to see the infant. He recognized on the child the thirty-two major and the eighty minor marks of a great man, which indicated that he was destined to become either a 'universal monarch' or a great teacher. The prophecy of Asita was the basis for the efforts of King Suddhodana to make life in the palace so pleasant that Prince Siddhartha would cling to it and eventually become the 'great ruler'. The scenes with many figures below the medallion depict successive stages of Asita's journey to Suddhodana's palace.

This is the story represented in the medallion of this slab from the Great Stupa of Amaravati. The king sits on the left, the sage Asita sits opposite him on a slightly lower level. They are surrounded by courtiers and attendants.

The Great Stupa (*Maha-Chaitya*) of Amaravati, recognized as the peak of Buddhist art in south India, is the earliest important establishment in the region. It is the largest, and, by its mature period (about the second half of the second century AD) the most lavishly decorated with sculpture of fine quality.

The legend of Amaravati's foundation as a result of the Mauryan Emperor's missionary zeal, is corroborated archaeologically by the discovery of a fragment of the polished quartzite pillar inscribed with an Ashokan edict. Many casing slabs depict the likeness of the stupa.

48

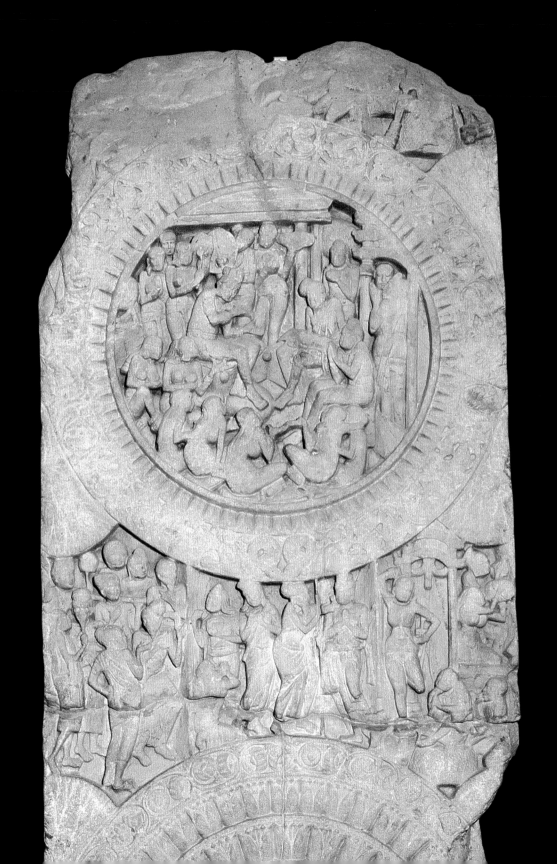

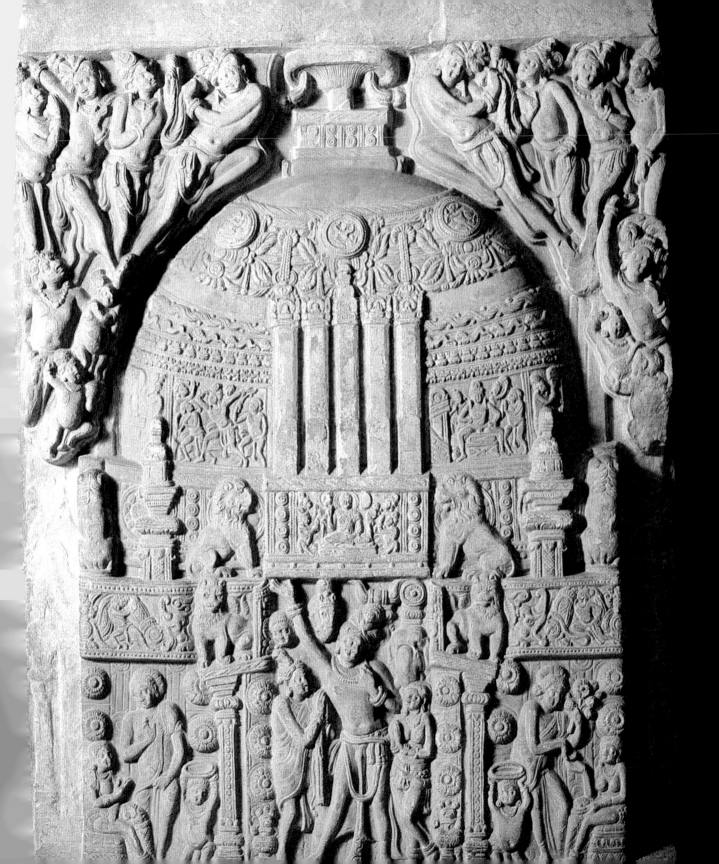

A Stupa in South India

IKSHVAKU, SECOND-THIRD CENTURY AD
CUDDAPPAH STONE, 121 X 91 CM
NAGARJUNAKONDA, ANDHRA PRADESH
NATIONAL MUSEUM, NEW DELHI

This sculptured panel from Nagarjunakonda, stands near the Krishna River, where the ruins of many stupas, as well as other Buddhist and Hindu structures, dating from the second-third century AD were found. It depicts a stupa of the type peculiar to south India. The *ayaka* platform on each of the four sides, surmounted by five columns, is the distinguishing feature. Unlike the *torana*, the gateway with the architrave of three lintels, as at Bharhut and Sanchi, the gateway here is formed on each of the four sides by the railing turning out at right angles. It is marked by a seated lion at the beginning and the end of the angle.

To allow the stupa to be seen clearly it appears raised above the railing which surrounds it. Two friezes of sculptured slabs, one above the other, decorate it. The bands above them and the decorations higher on the dome may have been modelled in plaster and painted. The *ayaka* platform is normally decorated with sculpture in stone. In this case it seems to depict a seated Buddha, flanked by other figures. The dome, as is usual, bears a square railing and from its centre rises an umbrella. The triangular spaces of the panel, on either side of the dome, are adroitly filled with figures in different poses.

The stupa of Amaravati, of a slightly earlier date, likewise had slabs depicting the stupa peculiar to the south, with the *ayaka* platform.

The sculptures of Nagarjunakonda are elegant and graceful and testify to the sure sense of decoration of the artists who fashioned them.

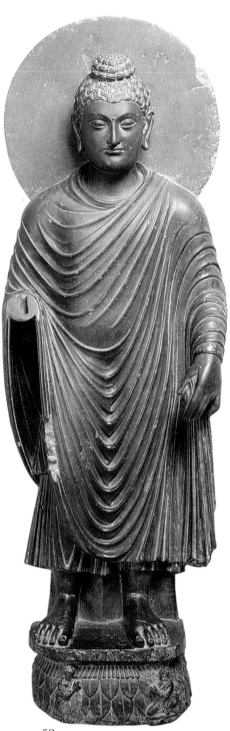

The Buddha

GANDHARA, SECOND-THIRD CENTURY AD
DARK GREY SCHIST, HEIGHT 110 CM
NORTH-WEST FRONTIER PROVINCE, PAKISTAN
NATIONAL MUSEUM, NEW DELHI

The Buddha stands firmly on a lotus-petal decorated pedestal. A small figure of a votary kneels at each front corner. The head of the Buddha, against a simple round halo, is covered with tight curls, and the head protuberance resembles coiled hair. The eyes are half closed; the ear lobes are moderately elongated, recalling the discarded jewellery. The dress consists of an upper garment over both shoulders falling in pleats from the neck. It is grasped below the waist by the left hand, and gathered in a tight fold at the elbow of the broken right arm. The lost right hand was undoubtedly in the gesture of reassurance, raised, with the palm turned outward. The lower garment falls in vertical pleats almost to the ankles.

The Bodhisattva (Maitraya)

GANDHARA, THIRD-FOURTH CENTURY AD
BLACK SCHIST, HEIGHT **84** CM
NORTH-WEST FRONTIER PROVINCE, PAKISTAN
NATIONAL MUSEUM, NEW DELHI

Unlike the Buddha, Bodhisattvas have postponed the search for their own salvation in order to assist others find theirs. They have not, in Gandhara sculpture, discarded their jewellery, but are often depicted as princes with moustaches and profuse ornaments. In this example, the head of the image is framed by a round halo; the garment is the pleated robe, falling only from the left shoulder over the arm, leaving the chest bare. It is decorated by a long necklace. The left hand holds a water pot, the usual symbol of the Maitraya, the Buddha of the future. The pedestal is decorated with two stylized round lotus blossoms.

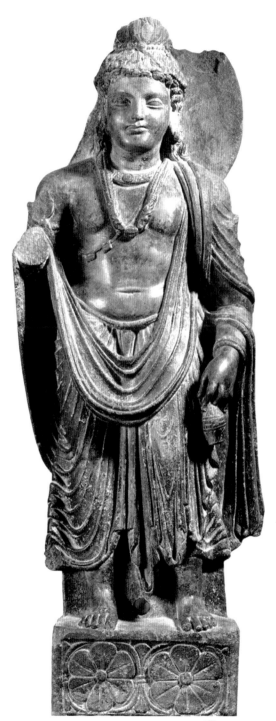

Head of a Youth

GANDHARA, SECOND-THIRD CENTURY AD

STUCCO, HEIGHT 22 CM

NORTH-WEST FRONTIER PROVINCE, PAKISTAN

NATIONAL MUSEUM, NEW DELHI

Gandhara sculpture at all periods was frequently carried out in stucco, especially for smaller subsidiary figures. Like the sculptures in stone they were painted. Modelled in soft gypsum, they are likely to be sensitive and expressive. This head of a young man might be a portrait.

There is a fillet, with ornaments in front, holding the hair in place. The young man is smiling gently and seems alert and relaxed. This is typical of many such heads, about the same size or somewhat smaller, invariably sensitively modelled. Many types of physiognomy were represented, often expressing stress or emotion.

54

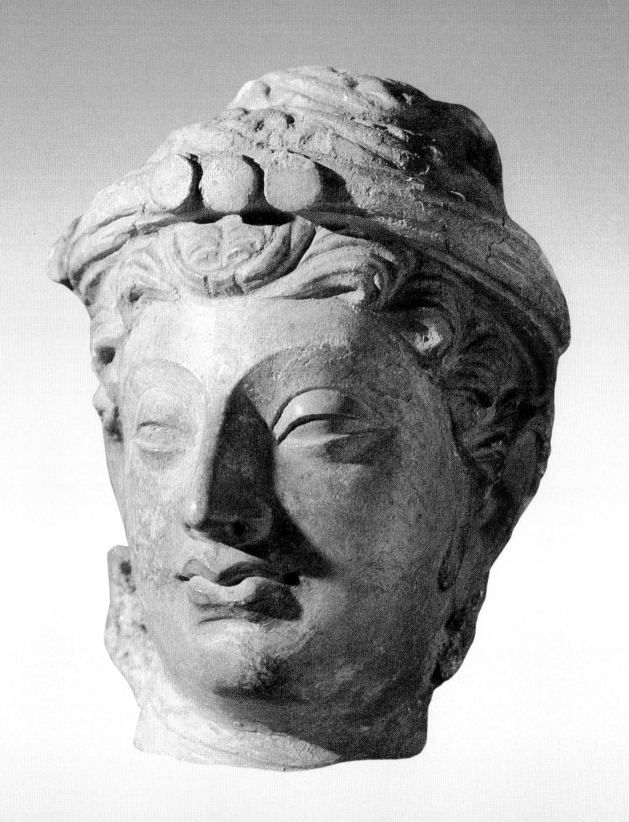

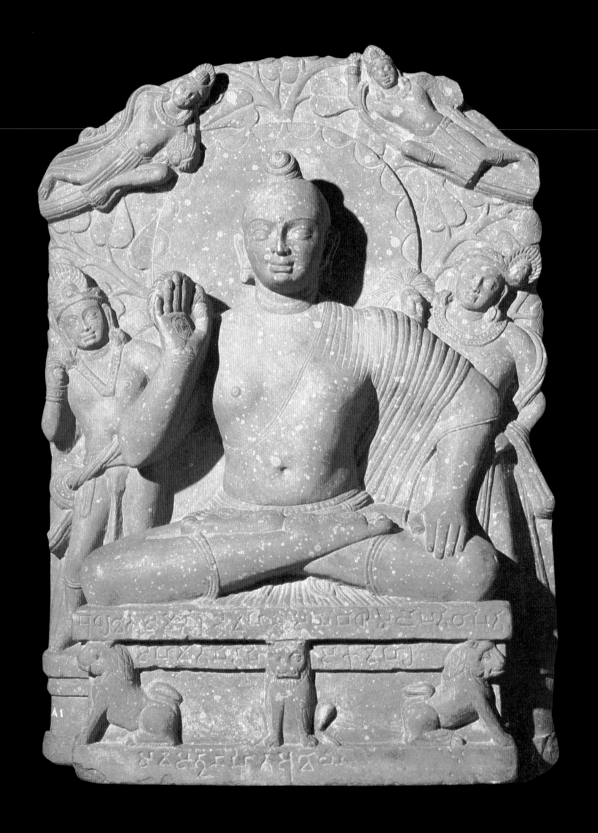

The Seated Buddha

KUSHAN, FIRST-SECOND CENTURY AD
RED SANDSTONE SPECKLED WITH BUFF, HEIGHT 71 CM
KATRA MOUND, MATHURA, UTTAR PRADESH
GOVERNMENT MUSEUM, MATHURA

Sculptures representing the Buddha, both standing and seated, from various periods and from different regions of the subcontinent, making traditional gestures and wearing the types of garments peculiar to each time and place, are illustrated in several plates. The prominence of Buddhism in art especially in the early periods in north India, produced a variety of forms and styles.

This early image of the seated Buddha, making the gesture of reassurance, is interesting for its handling of symbols associated with the Master, as well as for its vigour as a typical sculpture of the Kushan period at Mathura. The *ushnisha*, the protuberance on the head, is a spiral curl. An undated dedication in Brahmi characters, has been translated: *'Budharakshita's mother, Amoha-asi, has erected [this] Bodhisattva together with her parents in her own convent (or temple or monastery built by the Sakas), for the welfare and happiness of all sentient beings.'* It was customary in such dedications to include good wishes for the welfare of humanity as well as for those immediately concerned with the donation. The use of the word 'Bodhisattva' would seem to indicate that at this early period, this title was interchangeable with that of the Buddha, his assistance to others in attaining 'Enlightenment' being stressed. Behind him is the foliage of the pipal or the Bodhi tree. The gaze of the image is direct and gives no hint of introspection, and the broad shoulders and sturdy torso seem to recall the Yaksha sculptures.

Surya in Northern Dress

KUSHAN, FIRST CENTURY AD
RED SANDSTONE, HEIGHT 48 CM
KANKALI MOUND, MATHURA, UTTAR PRADESH
GOVERNMENT MUSEUM, MATHURA

The Sun God Surya wears the long coat, the trousers and the heavy boots made familiar by the famous headless statue of Kanishka, and other Central Asian portrait figures, carved in Mathura's red sandstone.

Originally this seated figure was thought to be a Kushan king or prince. It bears no inscription to identify it and the museum authorities, on the basis of scholarly study, now identify it as an early depiction of Surya. They point out that he sits in a chariot, with a horse on either side, the one to his right being badly damaged, and believe there are traces of a halo, now broken, behind him.

This earliest Surya, shown here, holds a dagger in its sheath, attached to his belt, and in his right hand, resting on the right knee, he holds a short club upright. He wears earrings and a necklace. The cap is decorated with what appears to be floral sprays, perhaps embroidered, and there is a band of fine embroidery, from the neckband to the belt, on the coat. He sports a small moustache and appears to be smiling gently.

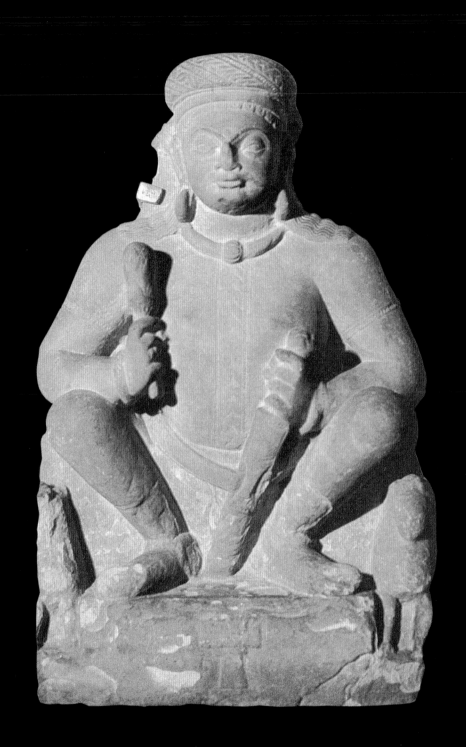

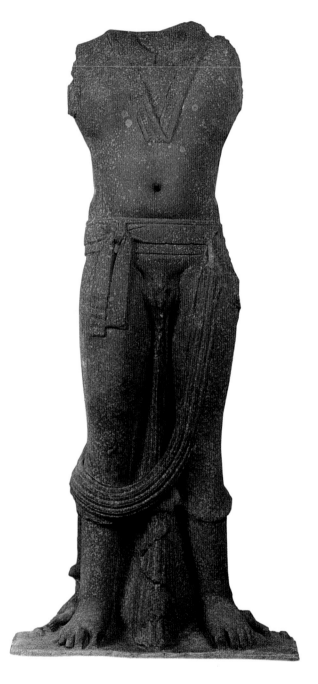

The Bodhisattva

KUSHAN, SECOND CENTURY AD
RED SANDSTONE SPECKLED WITH BUFF, HEIGHT 204 CM
MATHURA, UTTAR PRADESH
NATIONAL MUSEUM, NEW DELHI

This noble image in a firm frontal pose, its head and arms lost, retains nonetheless a majestic presence. Powerful, forthright, sparingly adorned, it is very different from the graceful, gracious, draped and richly ornamented Bodhisattvas of approximately the same date, sculptured in the northern territory of the Kushan kingdom, Gandhara, where Mediterranean influences were strong. It seems rather to be related to the few known Yaksha images, attributed to about the first centuries BC and AD, so often cited as evidence of an indigenous tradition of sculpture, distinct from Ashoka's elegant and technically accomplished likenesses of animals in the highly polished stone capitals of columns inscribed with his edicts. It recalls likewise, in its frank two dimensional emphasis, the figures carved on the posts of the Bharhut stupa's railing.

The details of the necklaces, the broad belt with the narrow cloth band and decorated ends knotted at the right, and the long sash descending from the waist, over the transparent lower garment, are carved with precision. They give a convincing sense of the qualities and characteristics of the materials represented. The bare torso, with the belly protruding slightly over the belt, has a sensitive roundness and softness, and conveys the impression of living flesh. In this treatment, avoiding the bone and muscle structure, the figure already conforms to the traditional depiction of the human form in Indian sculpture.

Four Tirthankaras

KUSHAN, FIRST CENTURY AD
RED SANDSTONE, HEIGHT 86 CM
MATHURA, UTTAR PRADESH
GOVERNMENT MUSEUM, MATHURA

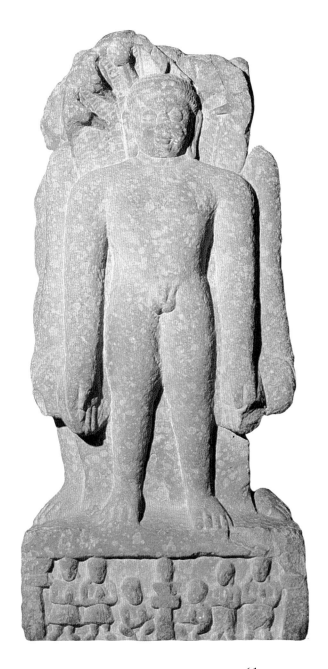

This early quadruple image of the four Tirthankaras, back to back, facing the four directions, is much worn by handling and weather, but already shows the distinctive features of the Jain standing figure—complete nudity, a rigid pose and arms hanging free from the body at either side. The figures on the base on all four sides are identified by the Government Museum in Mathura as devotees.

It should be recalled that the twenty-fourth and last Tirthankara was Vardhamana, called Mahavira, the Great Hero, by his followers, a contemporary of the Buddha.

Like the Buddha he was born a prince, son of the chief of a small state in north India, and though he married and had a daughter, at the age of thirty he renounced his aristocratic life and spent more than twelve years wandering, begging for food and performing austerities in order to attain salvation. As he had discarded all his clothing, the figures of all Tirthankaras ('Ford Makers' of Jainism), are usually represented nude. They bear the *shrivatsa* (jewel) mark on the chest. Early figures, with a few exceptions, have no distinguishing features. Later they were given attributes and are distinctive. They are normally represented as standing, undergoing long periods of rigid immobility as a penance, or sitting in meditation.

The Jain faith, unlike Buddhism, never spread beyond the subcontinent, nor did it disappear from India.

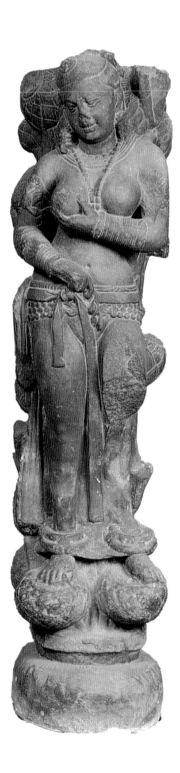

Sri Lakshmi

KUSHAN, FIRST CENTURY AD
RED SANDSTONE, HEIGHT 123 CM
MATHURA, UTTAR PRADESH
NATIONAL MUSEUM, NEW DELHI

The gracious Goddess stands on vessels overflowing with water from which grow the lotus flowers surrounding her and forming the background of the sculpture. With her left hand she touches her right breast, indicating it as the source of milk for her role as universal mother, as well as, symbolically, for the flow of water irrigating and enriching the earth. Though her face has been damaged, the beneficent smile is unmistakable. Her hair is elaborately dressed, she wears earrings, a flat necklace close to her throat and a long string of large beads falling between her breasts. Her arm bands are elaborately carved and multiple bracelets adorn her forearms. A skirt of transparent material, gathered into a series of pleats in the front at the centre descends from a scarf and a broad beaded belt, with tassels, to the ankles which are encircled by heavy ornaments.

Lakshmi is the consort of Vishnu, the divinity concerned with order in the universe, and she is regarded as the bestower of good fortune and prosperity.

Yakshi with Bird and Cage

KUSHAN, SECOND CENTURY AD
RED SANDSTONE, HEIGHT 129 CM
MATHURA, UTTAR PRADESH
INDIAN MUSEUM, CALCUTTA

This sculpture in red sandstone, of a female figure, with a bird on her left shoulder and holding a bird cage in her right hand, adorned the post of a railing of a small stupa. It has been reproduced frequently and was an especially charming example of the type of sculpture of the time. It is one of a group, from a Mathura site, of which the Yakshis, either with both feet on a crouching figure as in this piece, or in a dance pose on a similar crouching figure, carry a variety of objects. Above each one is a compartment of the pillar, like a window or balcony, on which other smaller figures are depicted in different activities.

All the figures on the posts wear what appears to be a transparent lower garment, draped in various ways, below a decorated belt. They have anklets and bracelets and necklaces of different types and their hair is arranged in a variety of styles.

A Jataka story is usually sculpted on the back of these posts, or there is the round form of the stylized lotus flower.

Those unfamiliar with Indian sculpture are often puzzled to find such representations of female beauty associated with religious structures.

The Indian idealization of the female form, as the Yakshi motif, is used in religious Indian architecture, Hindu, Buddhist, and Jain alike.

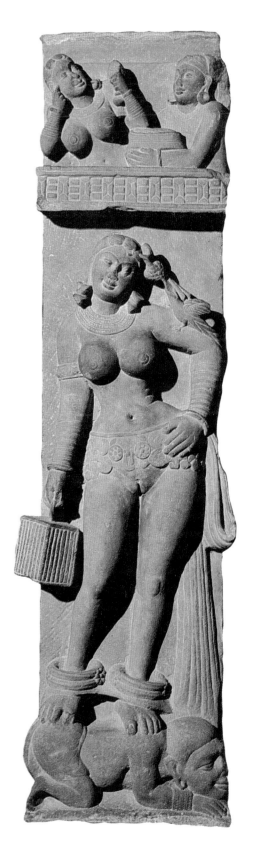

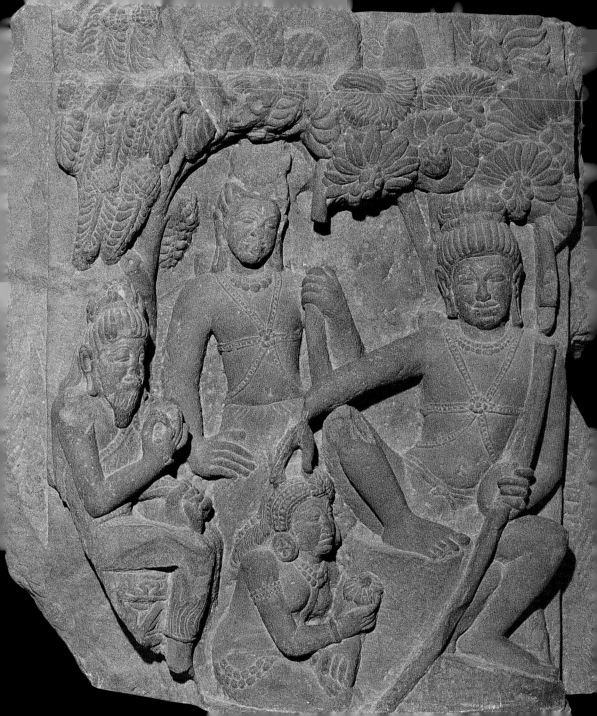

Rama Releases Ahalya from Gautama's Curse

GUPTA, SIXTH CENTURY AD

DARK RED SANDSTONE, 78 X 68 CM

DEOGARH, MADHYA PRADESH

NATIONAL MUSEUM, NEW DELHI

This panel from the platform of the Dasavatara Temple of Deogarh depicts an episode from the *Ramayana*. As Rama, with his faithful brother Lakshmana and the sage Vishvamitra approached Mithila, they noticed a beautiful, ancient, and apparently abandoned ashram. The Sage said that it had been the home of the great *Rishi* Gautama, and his beautiful wife, Ahalya, who was seduced by Indra. Gautama, discovering their sin, cursed them both. Ahalya was condemned to stay in the ashram, invisible, living on air, for a thousand years, while the *Rishi* went to the Himalayas. He prophesied, however, that Prince Rama would one day visit the ashram, when the curse would end and he would return to her, pardon her and live with her again as her husband.

On the sculptured panel this happy ending has just occurred. Lord Rama, is sitting at ease, blessing Ahalya who kneels before him. Seated in the left corner is the *rishi*, who has returned according to his promise. Lakshmana looks on benevolently.

Apart from the interest of the story, so graphically portrayed in high relief, the panel is an excellent example of the sculptor's skill in creating an effective composition in limited space.

The *Ramayana*, the ancient Sanskrit epic by Valmiki, is greatly loved by Indians. They enjoy its many interesting stories and revere the ethical and moral values it teaches as a basis for a virtuous life, considering its ideals still applicable today.

Life of the Buddha

GUPTA, LATE FIFTH CENTURY AD
PALE BUFF SANDSTONE, 86 X 49 CM
SARNATH, UTTAR PRADESH
NATIONAL MUSEUM, NEW DELHI

The principal episodes of the Buddha's life, sculptured again and again on slabs for stupas, or for their railings, have seldom been so neatly and economically summarized pictorially as in this panel. Three registers are preserved, except for the loss of the heads of the three large seated Buddhas. The part at the top, presumably portraying the Master recumbent in the *Paranirvana*, the death scene, has been broken off.

The panel is to be read from the lower left. Queen Maya Devi, Siddhartha's mother, is shown lying down. The small elephant that she dreamt had entered her body hovers above her. At the right, she stands clasping a branch with her left hand, and the child issuing from her slightly protruding right hip is received by Indra. In the centre, the child, in larger size, making the gesture of reassurance, stands on a long-stemmed lotus.

In the register above, from left to right, Prince Siddhartha is leaving the palace on his horse. At the far right, the future Buddha sits under an umbrella, on a lotus throne, meditating.

In the third register, above a narrow frieze, two seated figures of the same large size, represent the Buddha calling the earth to witness, by touching the ground with his right hand, symbolizing the 'Enlightenment'. To the right is the other Buddha with his hands in the teaching gesture, as he delivers the First Sermon in the Deer Park at Sarnath.

The seated Buddhas wear a transparent upper garment which falls without folds, in the Sarnath tradition. The undergarment, tied at the waist, can also be detected and the hems of both are indicated on the crossed legs.

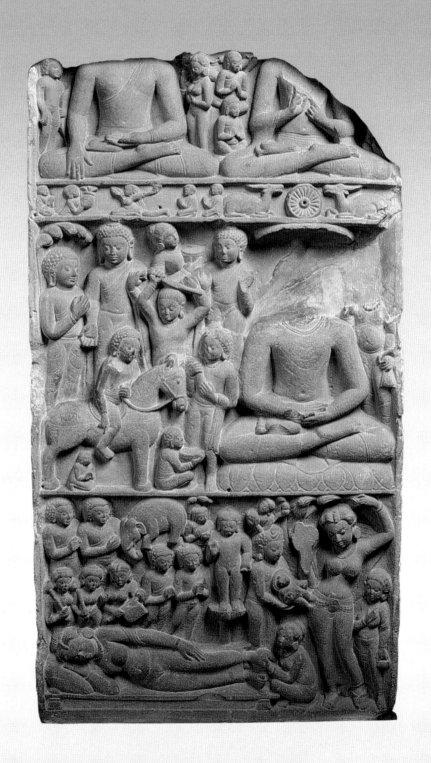

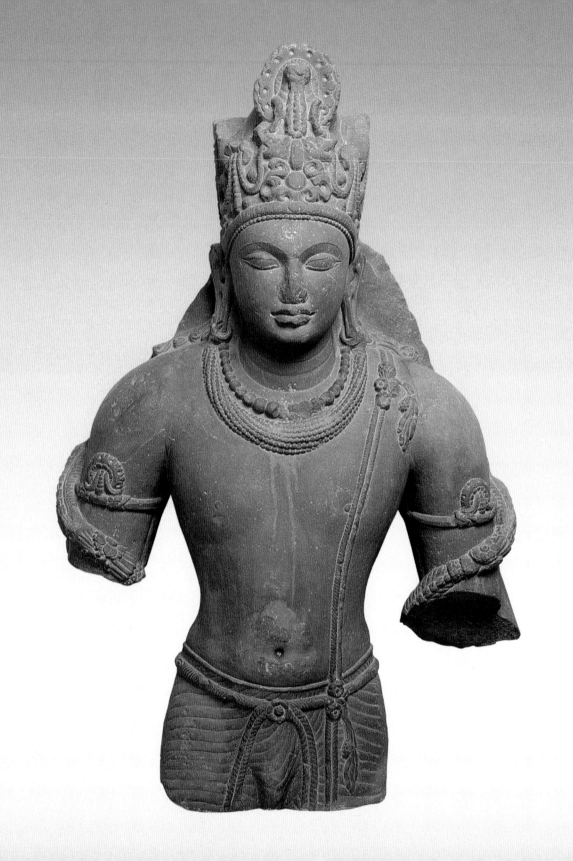

Vishnu

GUPTA, FIFTH CENTURY AD
RED SANDSTONE, HEIGHT 106 CM
MATHURA, UTTAR PRADESH
NATIONAL MUSEUM, NEW DELHI

This noble and elegant sculpture of the Hindu God Vishnu has the perfection of form and of the techniques of carving stone expected from Mathura in the classic Gupta period. In the characteristic red sandstone of the region, sensitively fashioned, it remains imposing despite the damage it has sustained.

The image wears a profusely ornamented crown. The torso is bare and a lower garment, textured with tucks, falls from the belt. Long earrings and two necklaces, frame the face.

By the Gupta period, Buddhism was still influential and inspired images, which must be recognized as outstanding works of art as well as powerful expressions of faith. But Hindu places of worship were increasing in number and needed images for worship. Mathura, for centuries a major centre for the sculpture of Buddhist icons, now called on its stone carvers to provide images of Hindu deities. The forms were different, but the high standards of the sculpture were maintained. This Vishnu image and the Standing Buddha alike represent the high achievement of Gupta sculpture in Mathura. It should not be overlooked, however, that under the benign rule of the Guptas other centres developed and were responsible for masterpieces of sculpture. The style, the type of stone and details of treatment differed, but the quality was maintained.

69

Gana

GUPTA, FIFTH CENTURY AD

RED SANDSTONE, 85 x 65 CM

NAGPUR, MAHARASHTRA

NATIONAL MUSEUM, NEW DELHI

Ganas are the dwarf attendants of Shiva. Their leader is Shiva and Parvati's son, the elephant headed god Ganesha, called Ganapati for this reason. They often play musical instruments and dance as they precede Shiva or surround him.

This image of a gana is unusual in its profuse adornment. He sits at ease, leaning his right arms on the bolster behind him. He wears a dhoti of thin pleated material spreading between his legs on his cushion. His pose and expression convey a sense of serene contentment, and the sculptured eyes seem to have a meditative gaze, withdrawn from the harsh external reality.

The figure is plump and seems ageless, the personification of abundance and the satisfaction of all material needs, at least.

As a composition it is particularly satisfactory in the balanced gestures of the four arms, and the strong diagonal of the lower left arm and raised knee in equilibrium with the weighty mass of the right side of the sculpture.

70

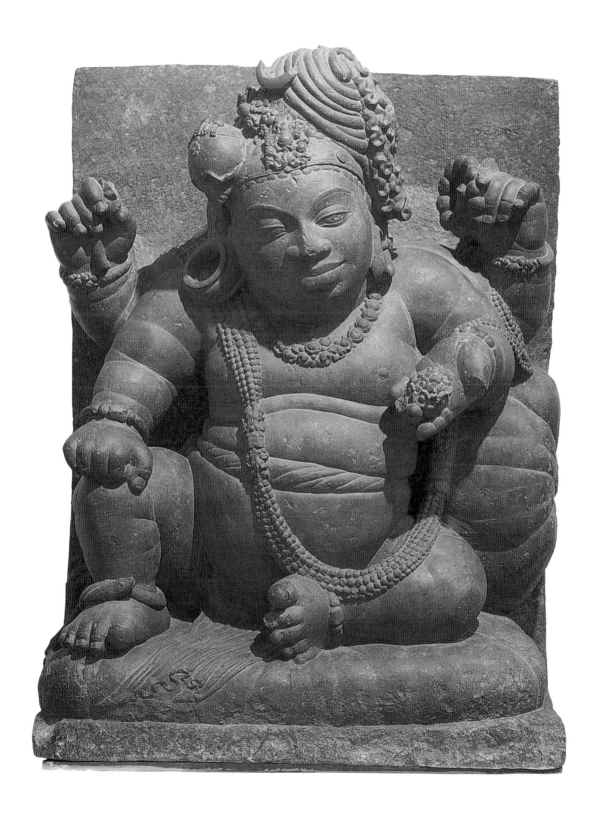

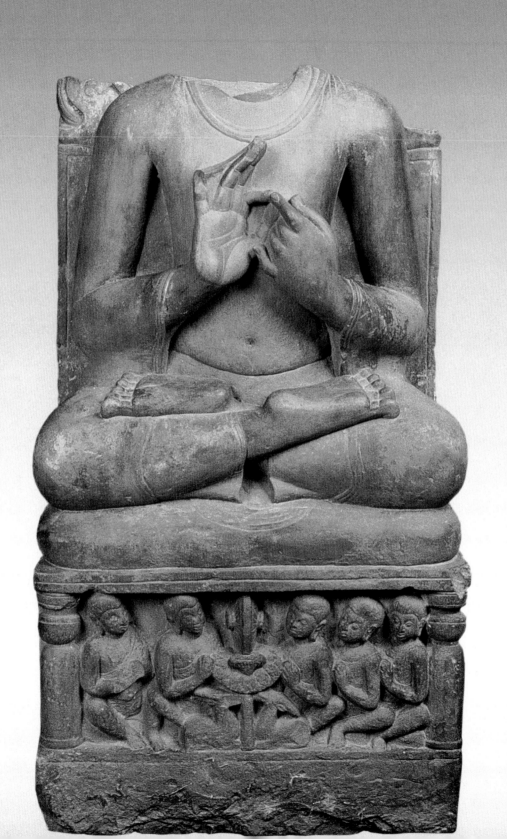

The Buddha Preaching in the Deer Park

GUPTA, SIXTH CENTURY AD
SANDSTONE PAINTED, 63 X 41 CM
SARNATH, UTTAR PRADESH
NATIONAL MUSEUM, NEW DELHI

By the Gupta period sculptors followed well-established conventions when representing the episodes in the life of the Buddha. Among the major events in his life, after attaining 'Enlightenment', is the First Sermon delivered in the Deer Park at Sarnath. The first auditors, according to legend were the five ascetics who turned against the future Buddha, when he renounced fasting as a means to achieve the knowledge which he sought, and finally did achieve by intense meditation at Bodh Gaya. The Sermon is described as 'Turning of the Wheel of Law'. It is normally symbolized by the representation of a wheel, while the location is symbolically indicated by figures of deer lying close to it.

When the Buddha himself is represented he holds his hands close to his chest, the right facing outward, the left slightly lower, and its back turned outward, the fingers touching the right in what, with many variations, is recognizable as the teaching gesture.

This sturdy figure, wearing the thin unpleated garment of the Sarnath tradition, with hems showing at the wrists and on the legs, in a realistic style, illustrates all the essential features of this episode. The head, probably against a halo, is lost.

The Sarnath Buddha

GUPTA, FIFTH CENTURY AD
PALE CHUNAR SANDSTONE, HEIGHT 160 CM
SARNATH, UTTAR PRADESH
ARCHAEOLOGICAL MUSEUM, SARNATH

The most celebrated and complete image of the Buddha, delivering the First Sermon in the Deer Park at Sarnath, is an outstanding example of the local style of the Gupta period. The image is slightly damaged, having suffered only some abrasion on the nose. The Master wears two transparent garments, without folds, in the north Indian style, their hems faintly indicated at the wrists and on the folded legs. His hands are in the typical teaching gesture and held rather low against the chest, the fingers of the outturned right hand joined by the webbing which is a part of the Buddhist legend of the special signs indicating his high destiny. The Buddha sits on a cushion, a part of his lower garment fanned out to form a circular pattern. On either side of the seat are rearing lion-like mythical beasts, leogryphs, as further signs of his pre-eminent role. The head, with elongated ear lobes, tight curls and a small *ushnisha*, the protuberance on his head, resembling a tight bun, is centred against a round halo, with a broad border of stylized plant motifs. Two celestial flying figures are represented on either side, near the top. The eyes are almost closed, concentrating on the inner vision and the lips seem to smile.

The event commonly referred to as the 'Turning of the Wheel of Law', is symbolically represented below the Buddha's seat, on its sturdy turned legs, by a wheel set in profile in the centre on a lotus pedestal, flanked by two deer, while there are figures, presumably including the five ascetics, on either side of it, kneeling with joined hands in an attitude of worship.

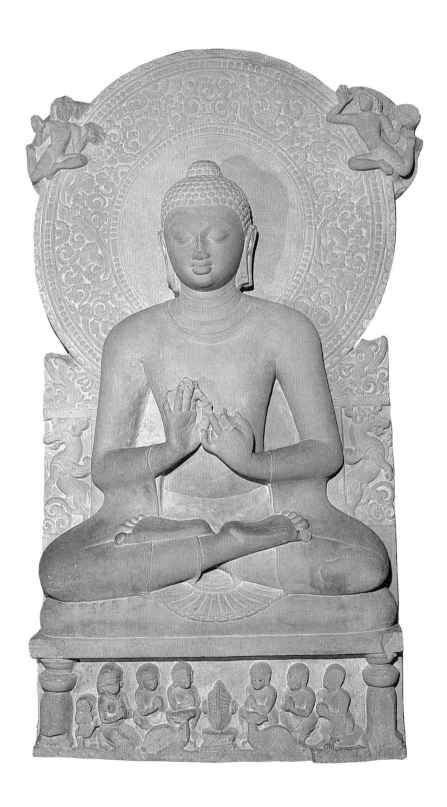

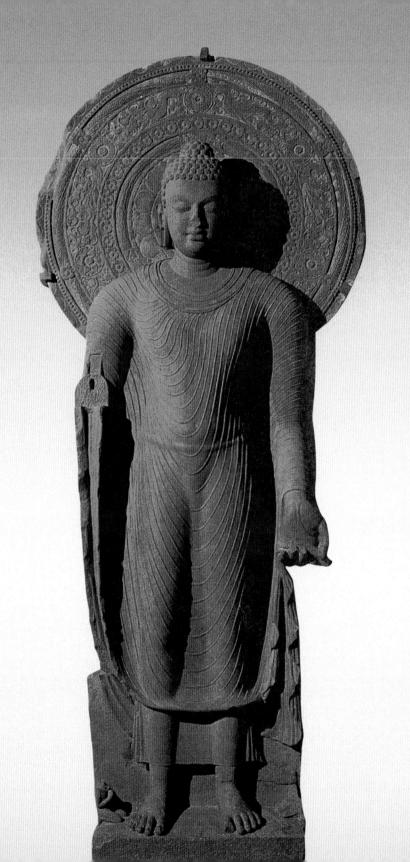

The Buddha

GUPTA, FIFTH CENTURY AD
RED SANDSTONE, HEIGHT 220 CM
JAMALPUR MOUND, MATHURA, UTTAR PRADESH
GOVERNMENT MUSEUM, MATHURA

This standing figure embodies all the established features of the Mathura image of the Gupta period at full maturity. The diaphanous robe, covering both shoulders, falls in pleats from the round neckband. The edge, grasped in the left hand, is looped over the right arm.

The equally thin undergarment can be detected underneath it, tied at the waist descending almost to the ankles. The head is delicately carved. It shows a serene smile, and the half closed eyes with the downward gaze of 'inward' vision. The *ushnisha* appears like a small tight bun. It is centred against the halo of concentric decorative bands. A minute devotee kneels on either side of the feet in an attitude of worship.

The pedestal is inscribed, and the Mathura Museum translates the inscription thus: 'This is the pious gift of the Buddhist monk Yasdinna. Whatsoever merit there is in this gift let it be for the attainment of the supreme knowledge of (his) parents, teachers and preceptors, and of all sentient beings.'

This Standing Buddha became a standard icon during the Gupta period. It was created in great numbers in various sizes for Buddhist places of worship. It has great delicacy and refinement. Details in the concentric bands of the halo may differ from image to image, but otherwise, there is little opportunity for the sculptors' invention. Skill is never lacking, but in some examples the freshness of creation seems dulled. No such reproach can be made in this case, however, for it seems to be a supreme example of its type.

Vyala and Rider Attacked

GUPTA, FIFTH CENTURY AD

BUFF SANDSTONE, 93 x 56 CM

SARNATH, UTTAR PRADESH

NATIONAL MUSEUM, NEW DELHI

This panel from the exterior of a temple depicts one of the fabulous composite beasts of the sculptor's imagination. The rearing animal is highly stylized, but some details suggest a lion.

A moment of tense drama is portrayed. The rider holds in his right hand an upraised sword and his left hand, stretched above his head, seems to grasp a coil of rope or a noose, presumably to assist in snaring an enemy. Is he aware of the danger underneath his mount? The kneeling figure, grasping the tail of the beast in his left hand, raises in his right a dagger to strike at the soft underbelly of the animal. The panel is notable for the ingenious disposition of the animal and the figures used to fill the restricted space.

The sculpture is in very high relief. The mythical creature, for all its stylized detail, is convincing in its pose, while the two human figures, more realistic in their representation, are skilfully carved to appear poised for violent action. The effect is at once dramatic and decorative.

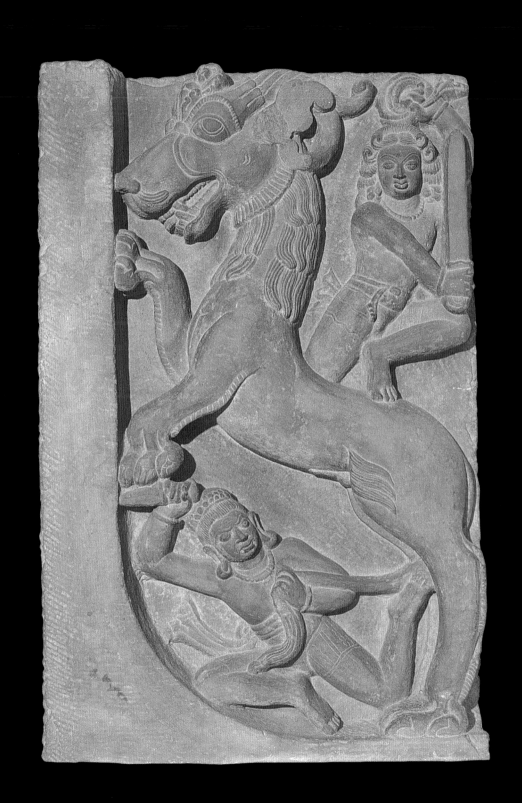

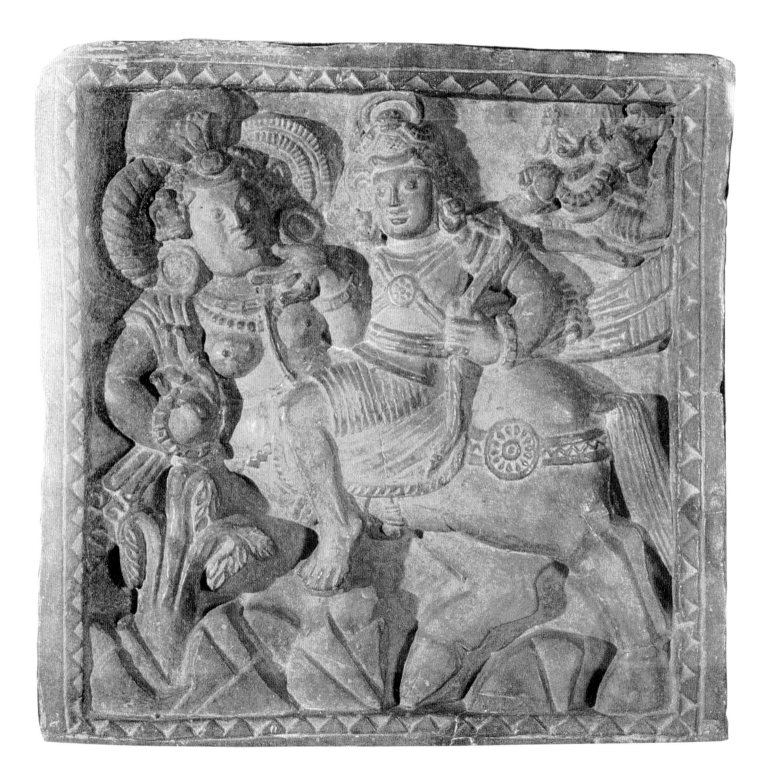

Vikrama and Urvashi

GUPTA, FIFTH-SIXTH CENTURY AD
TERRACOTTA, 67 X 67 X 14 CM
AHICHHATRA, UTTAR PRADESH
NATIONAL MUSEUM, NEW DELHI

This panel, exhibited as Vikrama and Urvashi, no doubt was originally affixed on the exterior of a brick temple of the Gupta period. Bhitargaon, near Kanpur, formerly survived as a good example of the happy association of the terracottas with the ruddy brick structures they adorned. This terracotta panel from another site, Ahichhatra, is a distinguished composition, elegant in execution, and in harmony with the aesthetic standards of stone carving prevalent at this period.

The subject has been interpreted in various ways, but perhaps not yet satisfactorily. One suggestion, which accounts for the title given here, used by the National Museum, New Delhi, which exhibits it, refers to the favourite story of the love of a mortal man for a heavenly nymph, a *gandharva* or *apsara*. He meets her by accident, falls in love and persuades her to share his life on earth. She consents, but insists that he observe certain conditions.

The story has several versions and details differ. It usually relates that the nymph's heavenly companions, after some time, desire her return. Therefore, they trick her devoted husband into breaking his vow. The nymph then disappears and the abandoned husband, disconsolate, wanders searching for her. He finally comes upon her sporting with her companions. She promises to appear to him again after the birth of their child. But she cannot return to his earthly life. He begs to join her, and finally, after submitting to many trials, practising austerities and performing difficult sacrifices, he is successful and is admitted to her realm of celestial beings.

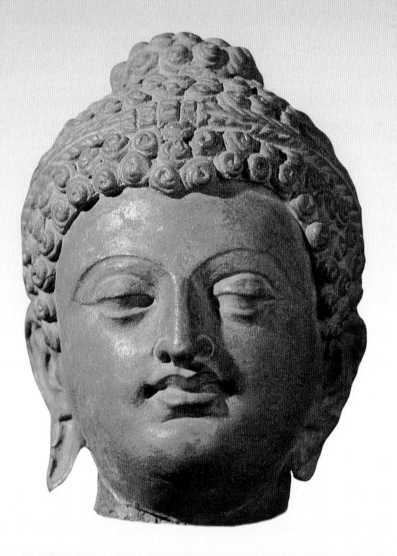

Heads of the Buddha and a Sage

GUPTA, FIFTH-SIXTH CENTURY AD
TERRACOTTA
BUDDHA HEIGHT 16 CM
SAGE (FACING PAGE) HEIGHT 14 CM
NATIONAL MUSEUM, NEW DELHI

Clay baked at a moderate temperature, becomes terracotta, durable, sturdy, and somewhat brittle. It is invaluable for the utilitarian vessels of all kinds for daily use. It becomes high art, however, between the fingers of a master modeller.

Of all the methods of creating images, terracotta modelling and firing are undoubtedly the most ancient techniques in India. Terracotta was much used in the Indus Valley civilization. It was used to craft religious figurines like the so-called Mother Goddesses—nude, with an elaborate headdress. It was also used to make small animals, toys of all kinds, glazed and handsomely painted jars and unglazed containers. Terracotta figurines of various styles, most commonly female, ranging from

crude cast or moulded bodies, features indicated by punched, pinched or appliqued details, to elegant representations of women with headdresses, ample garments and much jewellery, their faces modelled carefully for expressiveness, date from the sixth century BC or, possibly, even earlier.

It is in the Gupta period, however, that terracotta figures reached a high level of sophistication, rivalling stone in plastic quality. The two heads: of the Buddha and a sage, or an ascetic, respectively require little comment. The characteristics of the Buddha image were, by this time, well established at Mathura, Sarnath and elsewhere. Thus, the tight curls, with the bun representing the *ushnisha*, the ear lobes elongated by the heavy jewellery they once bore, the half-closed eyes that seem to look downward or inward, the serene and tender smile are familiar.

The sage is identified by his rolled-up long hair, moustache, beard and earnest gaze. Retired from worldly life, he devotes himself to religious exercises.

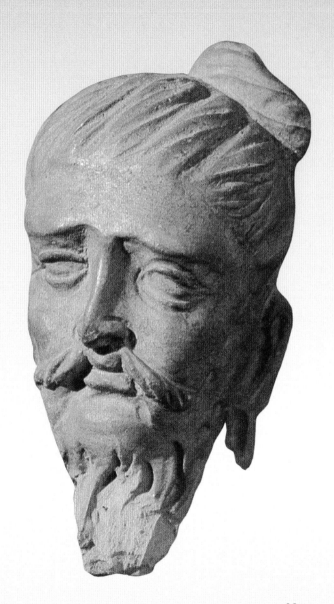

83

Shiva

GUPTA, FIFTH CENTURY AD
TERRACOTTA, HEIGHT 15 CM
AHICHHATRA, UTTAR PRADESH
NATIONAL MUSEUM, NEW DELHI

This head of Shiva in terracotta, though modelled from the humble material of baked clay, and small in size, must rank as a major work of art. Undoubtedly it represents what has remained unbroken from a figure on a brick temple, as the uneven edge at the neck seems to indicate.

This head of Shiva, alert, benign, with boldly modelled features and his hair piled high, sweeping upward over the face suggesting a crown, is impressive. No lengthy commentary is required to emphasize the divinity's commanding presence, secure in his power and representing reassurance and protection to his devotees. Similarly, the modeller's vision and the devotion that the sacred image inspired surely guided skilled hands to make its very creation an act of worship.

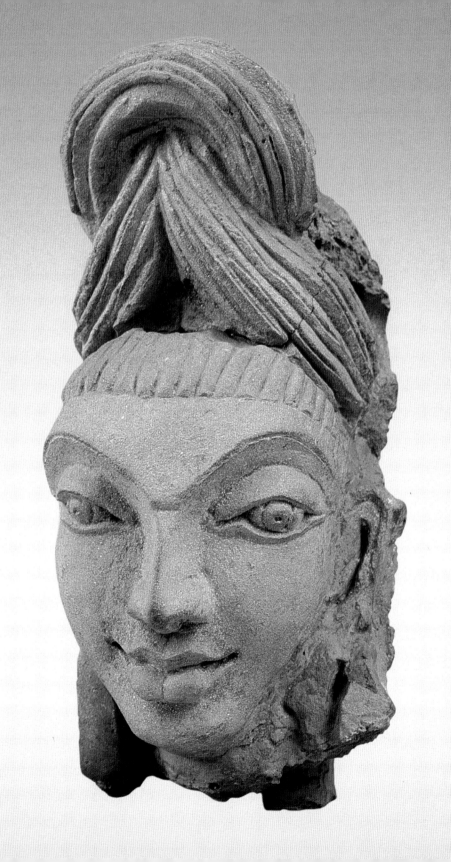

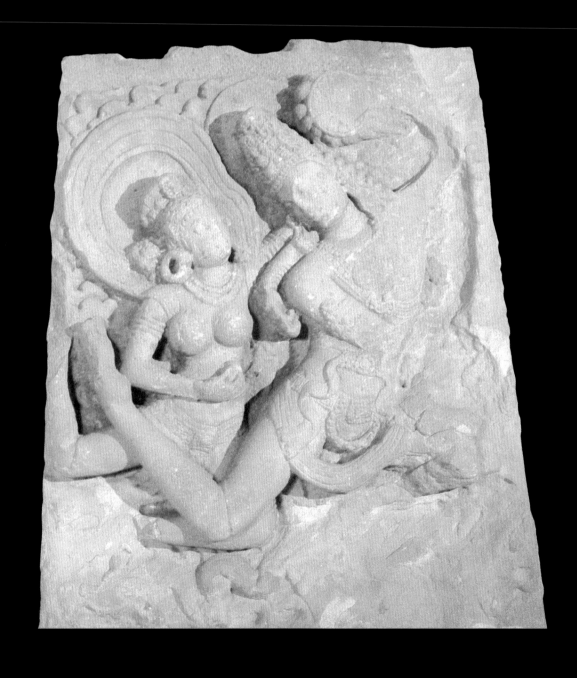

Flying Celestials

EARLY WESTERN CHALUKYA, SIXTH CENTURY AD
YELLOW SANDSTONE, 126 X 100 CM
AIHOLE, KARNATAKA
NATIONAL MUSEUM, NEW DELHI

Gandharvas, or *supernas*, mythical winged beings, sometimes playing musical instruments, or as a couple, a *vidyadhara* and a *vidyadhari*, flying attendants scattering flowers over a divinity, are often represented on temple walls in the Gupta and early medieval periods. They are graceful and seem completely at ease in the air, wearing crowns and jewellery, their diaphanous garments fluttering behind them to suggest their rapid but airy motions.

Purely ornamental elements of temple decoration, they are a satisfying design, but have no great iconographic message.

The Trimurti of Mahadeva, Elephanta

RASHTRAKUTA, EARLY SEVENTH CENTURY AD

BROWN SANDSTONE, HEIGHT OVER 4 M

ELEPHANTA, MAHARASHTRA

ELEPHANTA, ADMINISTERED BY THE ARCHAEOLOGICAL SURVEY OF INDIA

Among the rock-hewn masterpieces of sculpture in cave temples, the colossal stone carvings in the temple dedicated to Shiva on the island of Elephanta, near Mumbai must be counted among the greatest in India. The exact date of the cave, with its columned hall and the shrines and episodes of the Shiva legend sculptured on the walls, is unknown. On stylistic ground it is generally considered to belong to the early seventh century.

Most of the sculptures were damaged by vandals soon after the discovery of the temple by Europeans. The Trimurti of Mahadeva, the three-faced image of the Great God to whom the temple is dedicated, has fortunately suffered little damage. It terminates a long vista through the hall of columns and, more than four metres in height, it dominates the shrine. A major tourist attraction no longer in worship, it retains nonetheless, a sense of sanctity as well as majesty.

The Trimurti represents three aspects of Shiva. The central image of the head and shoulders of the divinity is withdrawn from the world, remote but benign. The eyes are closed. The high crown is textured by ornaments in low relief. The head is framed by earrings and a broad necklace at the base of the throat.

At the left, seen in profile, is the terrific aspect of the God, Bhairava, of equal dimension, but with a lower crown, also ornamented. The eyes are closed, but the cruel mouth is curled under a moustache. In profile, at the right, is the tender aspect of the deity, feminine in personification, wearing a low, jewelled crown and holding a flower. The face is of the same dimension as that of the central figure and the eyes are closed.

The composition is monumental, and it has been sculpted into the stone wall of the cave with the greatest sensitivity, despite its great size.

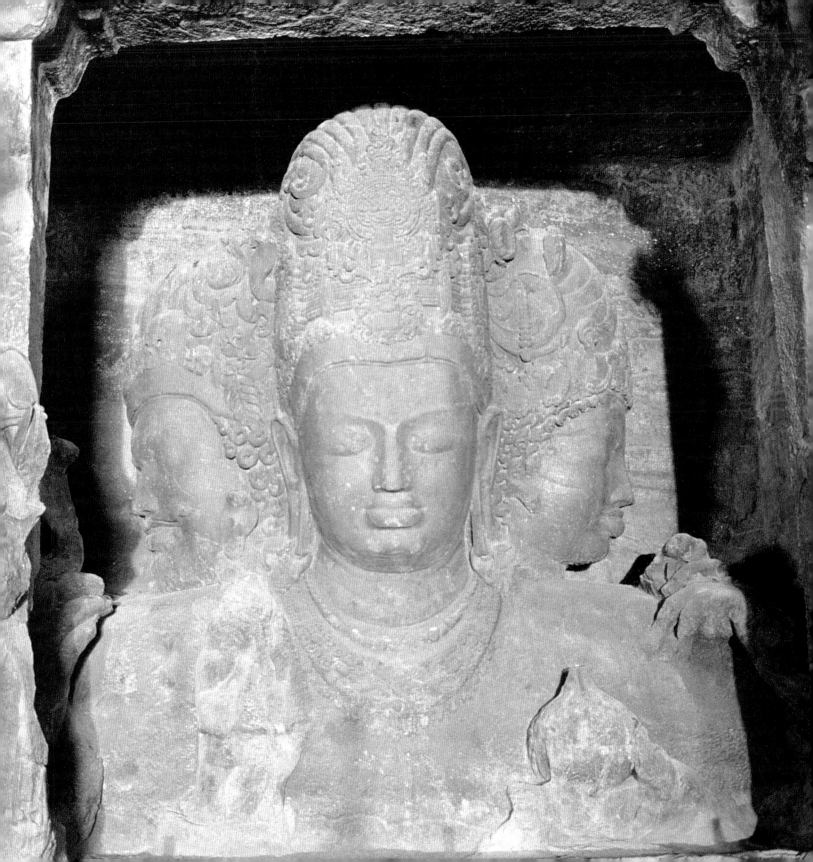

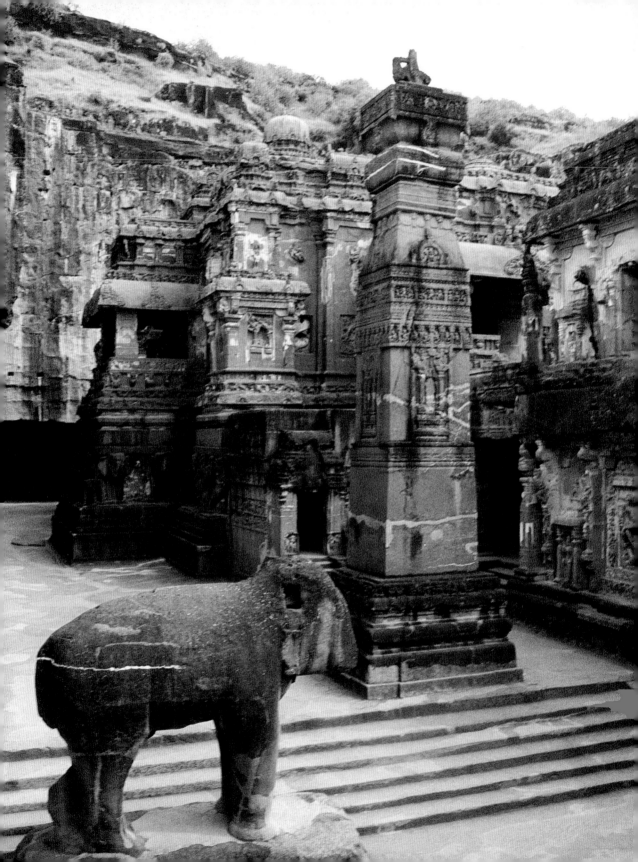

The Kailasha Temple, Ellora

RASHTRAKUTA, EARLY EIGHTH-NINTH CENTURY AD

DARK VOLCANIC STONE

ELLORA, MAHARASHTRA

IN SITU, ADMINISTERED BY THE ARCHAEOLOGICAL SURVEY OF INDIA

The Kailasha Temple, Cave number 16 of the series of rock-hewn cave temples at Ellora, stands almost midway among them, following the twelve Buddhist caves, which begin the group and date from the fifth to the eighth centuries. It is the most important of the caves dedicated to Hindu deities, dating from the seventh and eighth centuries, and is unique at Ellora as a complete temple, free-standing, carved from the dark volcanic stone of the hill. The group of five Jain cave-shrines, dating from the ninth to the eleventh centuries, terminates the series.

The Kailasha Temple dates back to the early eighth century and was commissioned by a king of the Rashtrakuta dynasty. Instead of being carved into the hill of stone, it was planned as a temple to stand in the approximate centre of the large courtyard cut into the hill, with a back wall twenty-five metres high, and measuring approximately seventy-three metres deep and forty-six metres wide. The temple itself is nearly twenty-five metres high on its solid plinth which is about six metres high, and it is about fifty metres long and thirty-two metres wide.

In these monumental dimensions the Kailasha Temple, dedicated to Shiva, stands out as an unmatched architectural masterpiece in sculpture. The solid plinth, appearing as support of the sculptured chambers of the temple, connected by bridges carved in the stone, is decorated by colossal elephants and other animals. The outer walls of the temple as well as its interior walls are ornamented by sculptured divinities and by bas-reliefs of a variety of subjects, including episodes from the *Ramayana*. Traces of painting still survive in some fragments in the temple, one part dating from the period of its fashioning and the remaining small part from a later period.

However impressive in size and in richness of sculptural embellishment the Kailasha Temple is, the quality of the sculptures throughout, including those of the corridors cut into the walls surrounding the courtyard, accounts for the universal admiration the Temple enjoys as an outstanding achievement in sculptured architecture, both as an entity and in its details.

The picture shows an enormous statue of an elephant near one of the two fifteen-metre high decorated pillars which stand on either side of the Nandi shrine. A corner of the Temple on its lofty plinth, is well lit to show the carvings, while the remainder is in the shadows. We can also see a part of the back wall, more than twenty-five metres high, cut into the hill, and a section of the hilltop with some bushes and trees growing on it.

Ravana Attempts to Overturn Mount Kailasha, Ellora

RASHTRAKUTA, EIGHTH CENTURY AD

VOLCANIC STONE

ELLORA, MAHARASHTRA

IN SITU, ADMINISTERED BY THE ARCHAEOLOGICAL SURVEY OF INDIA

Mount Kailasha in the Himalayas is traditionally the home of Shiva and Parvati and their sons. They are Ganesha, the elephant headed god, instrumental in overcoming obstacles, and Skanda, God of War, General of the Army of the gods, also called Kartikeya, in memory of the six mothers who reared him.

The legend portrayed in this sculpture has various versions, each differing slightly from the other in details, but agreeing in referring to the anger of Ravana, the Demon King of Lanka. He expresses his rage by trying to shake and overturn Mount Kailasha. Ravana appears below, with his ten heads and multiple arms while Shiva, Parvati and various attendants are above. Parvati has grasped Shiva's arm in apprehension at the Demon King's initial success in shaking their mountain home. Shiva is not worried but presses down on Ravana with his toe and thwarts his efforts, thus capturing him beneath the mountain. The sculptures are in high relief and almost free-standing in this niche on the north side of the Temple.

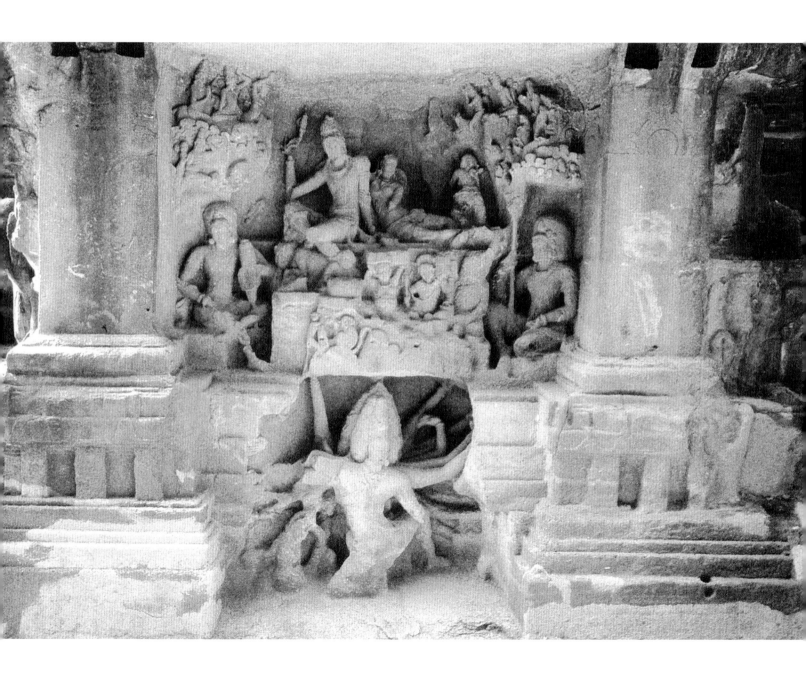

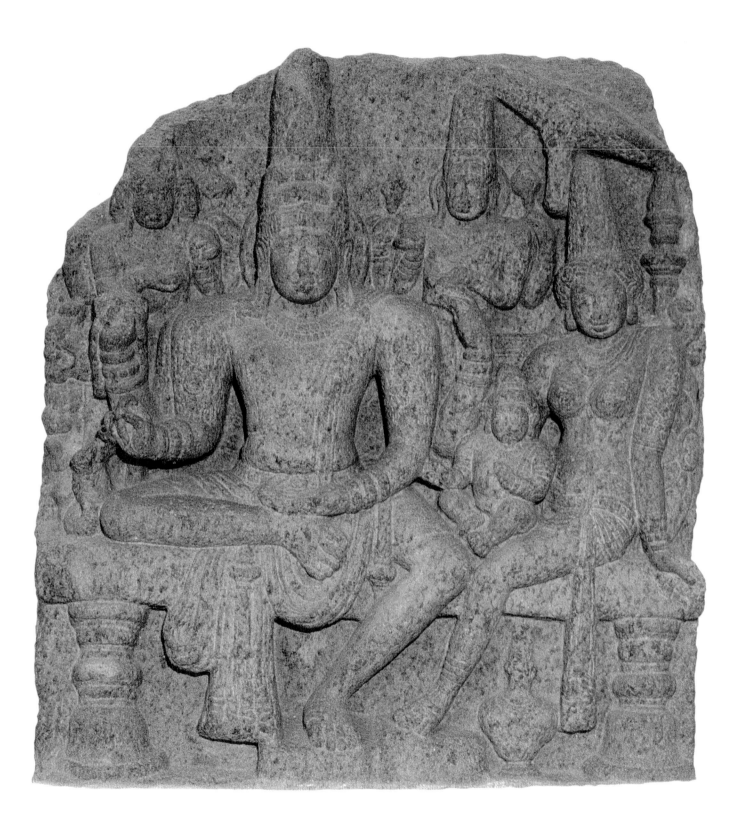

Shiva with Parvati and Skanda: Somaskanda

PALLAVA, SEVENTH CENTURY AD
GRANITE, HEIGHT 118 CM
KANCHIPURAM, TAMIL NADU
NATIONAL MUSEUM, NEW DELHI

This sculptured block depicting Shiva, Parvati and Skanda comes from the rear wall of the sanctum of a Pallava rock-hewn temple dedicated to Shiva. It thus forms the background to the symbol of the God, the *linga* placed in the centre of the shrine. This sculpture of the three divinities in the sanctum is a feature peculiar to the Pallava temples.

In this sculpture Shiva sits at ease on the throne, with Parvati, relaxed, seated to his left, holding the infant Skanda in her lap. An umbrella can be seen above her. The Gods, Brahma, three of his four heads showing, and Vishnu, stand in attendance behind the throne to the right and left of Shiva.

The composition and grouping of the figures and the play of mass and detail are particularly satisfactory in the strongly textured stone.

Vishnu

PALLAVA, SIXTH-SEVENTH CENTURY AD
GRANITE, HEIGHT 208 CM
POSSIBLY KANCHIPURAM, TAMIL NADU
NATIONAL MUSEUM, NEW DELHI

This four-armed Vishnu holds the discus and the conch in the rear hands of the upraised arms. He clasps his belt with his front left arm and the right arm comes forward with the hand in a gesture of reassurance. The deity wears a high crown, and has earrings, arm bands and bracelets. A long heavy dhoti falls from the belt below the slender waist almost to the ankles.

As the god ensuring order in the universe, the calm dignity and benign smile of the tall image give support to the reassuring gesture. It stands, appropriately, at the entrance to the exhibition galleries of the National Museum, New Delhi.

96

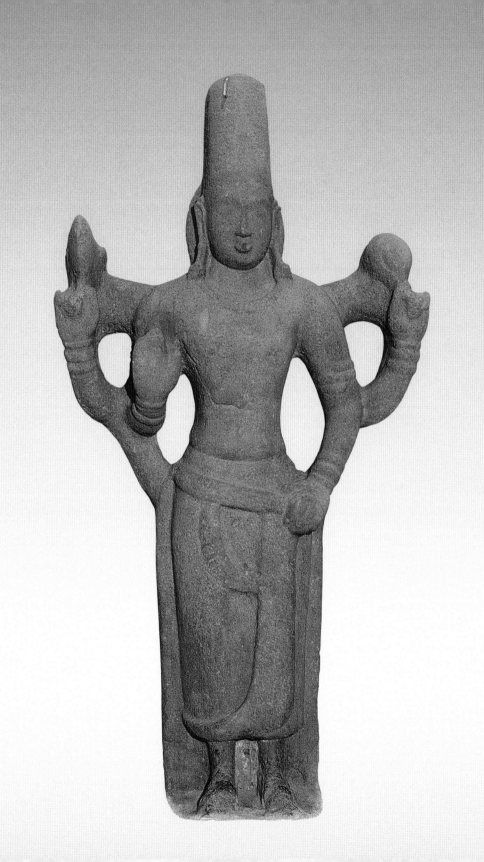

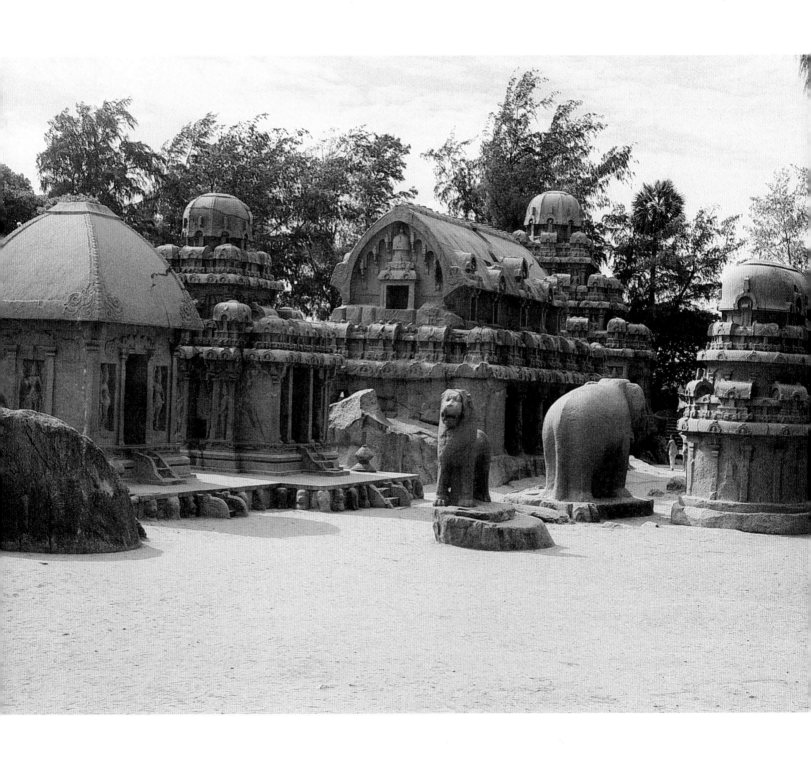

Rathas of Mahabalipuram

PALLAVA, SEVENTH CENTURY AD

GRANITE

MAHABALIPURAM, TAMIL NADU

ADMINISTERED BY THE ARCHAEOLOGICAL SURVEY OF INDIA

The Pallavas, the dominant rulers in south India from about the fourth to the early tenth century, created a large number of temples for the Hindu deities throughout their kingdom. The cave temples, carved from hills and cliffs during the early part of their reign gave way to structural temples by the eighth century.

The most spectacular group of Pallava monuments is at Mahabalipuram, their seaport. Under royal patronage, a rocky hill, an adjacent cliff, and granite outcrops and boulders were transformed into impressive works of art. The hill has cave temples at its base and on its flanks. The cliff, adjacent to the hill, carved into a huge bas-relief is unique. The bas-relief, the hill and five monolithic shrines and a few colossal animals, in a compact group nearby, represent the range of the sculptural achievement of the Pallava period, and date principally from the seventh century.

The monolithic shrines, carved from boulders, are known as *rathas*, 'chariots'. They reproduce the temple architecture of the time, from the small square shrine, represented with a thatched roof, to the elaborate temples of several storeys, with a variety of roof styles. Most are decorated with fine sculptures of door guardians and of divinities on the exterior, and some have sculptures in the sanctum as well.

As if to complete the range of the evolution of temple architecture during the Pallava period, the Shore Temple, an early eighth century structural temple, attributed to the reign of Narasimhavarman II (*c.* 690–715), is also at Mahabalipuram.

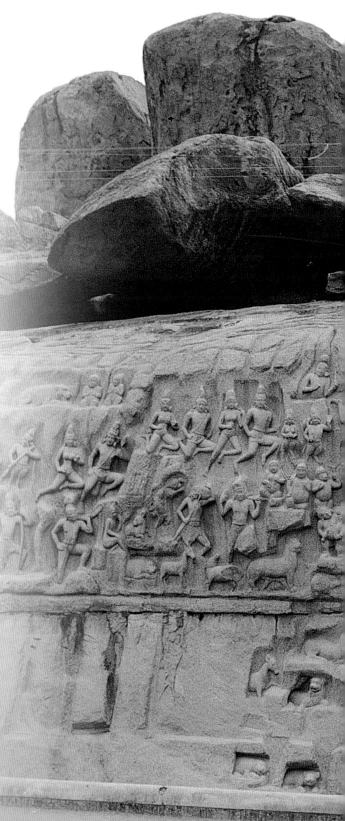

The Monumental Bas-relief

PALLAVA, SEVENTH CENTURY AD

GRANITE, 8 x 30 M

MAHABALIPURAM, TAMIL NADU

ADMINISTERED BY THE ARCHAEOLOGICAL SURVEY OF INDIA

This mural decoration in low relief, sculptured on the cliff face, so large in size and crowded with so many figures of divinities, of men in a variety of occupations, and of animals, appears to be intended to illustrate some theme. But there is no agreement on the possible subject. On the basis of a figure standing on one leg, arms raised above his head, at the left of a four-armed Shiva with Ganas, Arjuna's Penance has been suggested as a title. This would recall a story in the *Mahabharata*, in which Arjuna seeks Shiva's favour through the practice of austerities in order to win a magic weapon. Another, and possibly more acceptable suggestion, is that it refers to the descent of the Ganga to earth. The natural cleft between the two parts of the relief is clearly intended to represent a river, as a Naga and a Nagini, with widespread hoods, commonly accepted as water deities, are carved in it. This is an event which would inspire the divinities to rush to the spot rejoicing, as they seem to be doing here.

The men seem to be worshippers and sages in various poses. It is, however, the depiction of the animals delineated with sympathy and realism, which makes so profound an impression. This is particularly striking in the case of the group of colossal elephants at the bottom of the right-hand panel. The treatment of the huge animals is realistic, but conveys, not only their form and character, but, with some delicacy, seems to suggest the surface quality of the heavy skin, the flapping ears and the smooth tusks.

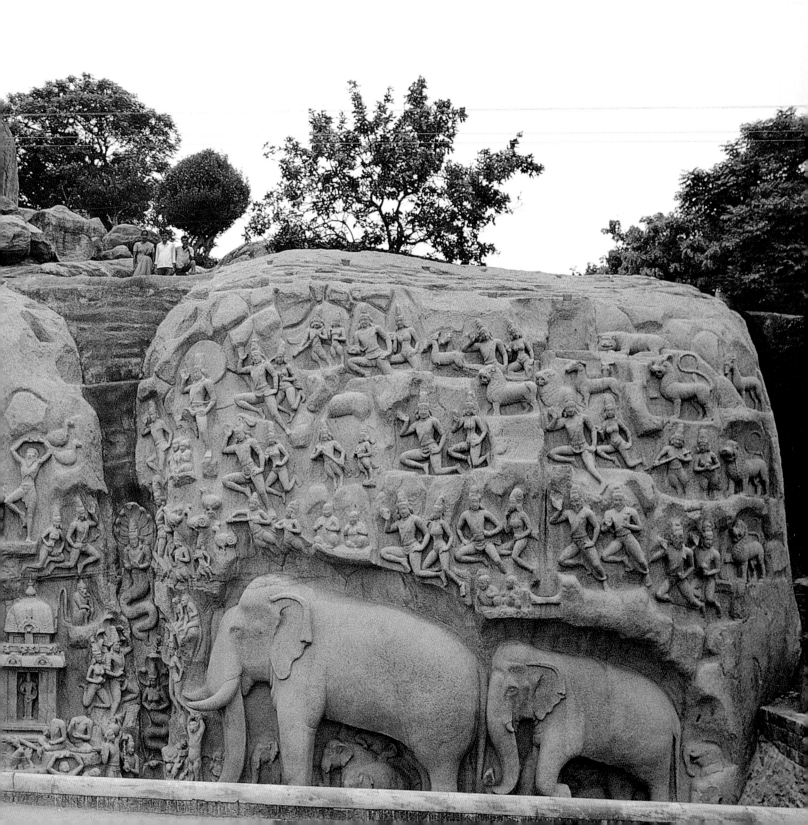

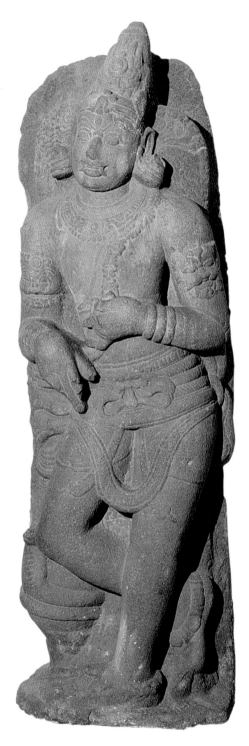

Door Guardian

CHOLA, TENTH CENTURY AD
GRANITE, HEIGHT 177 CM
MADRAS, TAMIL NADU
NATIONAL MUSEUM, NEW DELHI

The Cholas, who succeeded the Pallavas to power in south India in the tenth century, continued the use of granite for their sculptures in stone. Temples normally had door guardians—large, somewhat fierce figures, often with tusks—standing at either side of the temple entrance to protect it.

This guardian, one of a pair, wears an abundance of jewellery and stands relaxed, leaning against a large club. The figure facing him also leans on a large club, in a complementary but not symmetrical pose.

Nataraja

CHOLA, TENTH CENTURY AD
BRONZE, HEIGHT 71.5 CM
THIRUVANGULAM, TAMIL NADU
NATIONAL MUSEUM, NEW DELHI

Shiva as the divine dancer, the King of Dance, represents both creation and destruction, and the dance establishes the rhythm of the universe. It is an image carved innumerable times, at different periods, in stone, representing the God in a great variety of dance poses. Sometimes, with two or four arms, but often with more, especially in later periods, the image is dynamic and commanding and greatly revered.

The Chola bronze casters, at the height of their

aesthetic achievement, from the tenth through the twelfth centuries, interpreted the Nataraja in a variety of ways though it generally took a standard form. The Nataraja, during this period, has four arms, the right rear hand holding the *damru* the small hand-drum, marking the rhythm of the dance, and the rear left holding the flame, symbolizing both destruction and creation. The left forward arm crosses the body, either held at ease or when the left foot is raised, pointing to it. The right hand makes the gesture of protection or reassurance.

In this early Chola bronze the divinity is represented in the *catura* pose, that is, the legs form a square. Frequently depicted in stone sculpture of different periods and places, it is a rare pose in Chola bronzes. As is usual, the feet push down on the dwarf figure holding a snake, variously interpreted as symbolizing evil or ignorance. Though the dancing figure has neither the spreading hair nor the flying scarf sometimes added to suggest the vigour of the dance, the tassels falling from the belt and swinging outward suggest brisk movement. The God wears a high crown, a large round ring on his left ear, a profusion of other jewellery and the sacred thread falling from his left shoulder. He wears a benign and reassuring smile.

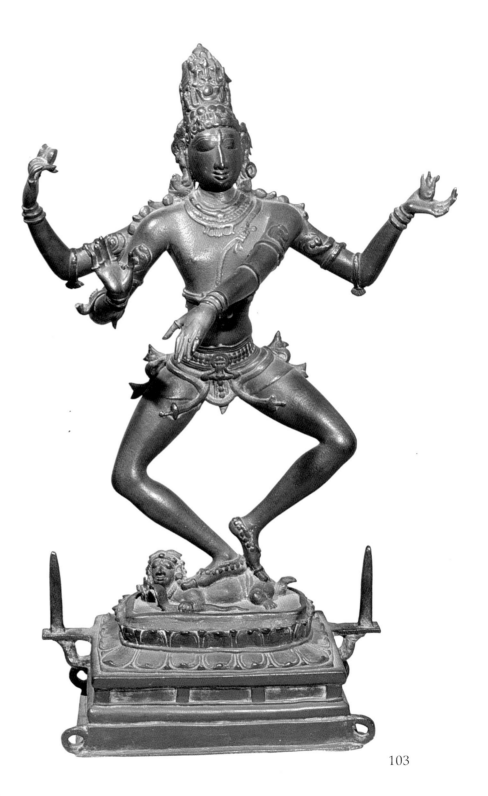

103

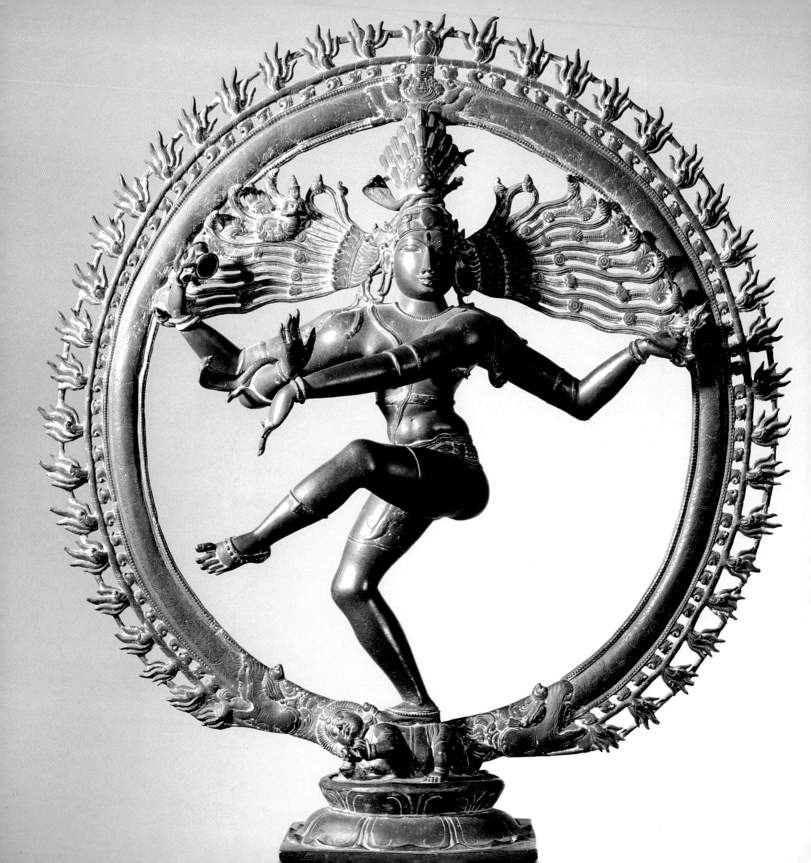

Nataraja

CHOLA, TWELFTH CENTURY AD

BRONZE, 98 X 84 CM

TANJORE, TAMIL NADU

NATIONAL MUSEUM, NEW DELHI

The usual representation of Shiva as the King of Dance, in the Chola period, depicts him encircled by a ring of fire, with his left foot raised and hair streaming out from either side of his head under a crown bearing traditional symbols. A small image of the River Ganga is frequently placed at the God's right on the streaming hair. This recalls the legend that when the great river was brought to earth the God received the shock on his own head. The Nataraja's arms are in the positions described earlier. The dwarf, a representation of evil or ignorance, is always under the right foot.

As the bronze casters modelled the figure in wax, then covered it with a strong clay mould, into which the molten copper was poured as the wax ran out, reproducing exactly the wax image, no two pieces are exactly alike. The sculptors were guided by conventions which stipulated that certain symbols should appear but they obviously had considerable latitude in modelling the image. Hence they strove to make it, and the dwarf crushed in the dance, as expressive as possible.

The composition of the metal changed somewhat with the passage of time. However, in later periods, when a number of metals were melted together to form an alloy, copper still remained the dominant component.

Metal images were subsidiary figures in a Shiva temple, placed in a subordinate shrine. But their principal function was to represent the deity during processions at certain festivals when they were carried out or, mounted on a temple car, were drawn out, to be shown to their votaries. They were then clothed in colourful textiles, had jewelled crowns and were decorated with rich jewellery and other ornaments.

Vishnu

CHOLA, TWELFTH CENTURY AD
BRONZE, HEIGHT 89 CM
TANJORE, TAMIL NADU
NATIONAL MUSEUM, NEW DELHI

In contrast to the dynamic Nataraja is the image of Vishnu, the protector and preserver of order. He appears most frequently standing serenely as here, making his gesture of reassurance. The God wears heavy lower garments typical of other bronzes of the late Pallava and the early Chola periods. In the right rear hand, he holds the discus, and in his left the conch. The front right hand makes the gesture of reassurance. The image is solid and stable, appropriate to the divinity's protective role. In the Chola period the metal image of Vishnu, intended to be carried in processions, was placed in front of the large permanent stone image in the sanctum. Daily worship and services were provided for both.

Like other Chola bronze images, this Vishnu is solid-cast by the lost wax process. In early periods the modelling of the wax image and the careful covering of it with the clay mould are reported to have been so precise that when the mould was broken very little chiselling was required. In later periods workmanship was less careful and a greater amount of chiselling was generally necessary to remove defects and produce a finished image.

The Vishnu legend describes how in his role as protector and preserver of order, Vishnu came to earth in various forms when it was necessary to overcome evil and disorder. Thus he appears as Varaha, the Boar, rescuing the Earth Goddess from the sea, and as Rama, hero of the *Ramayana*.

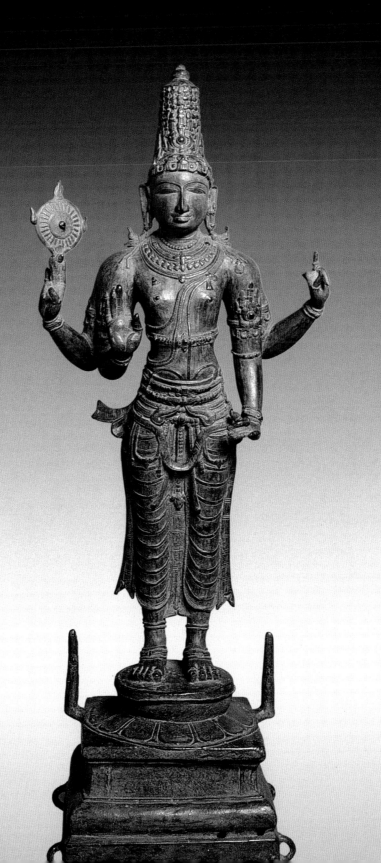

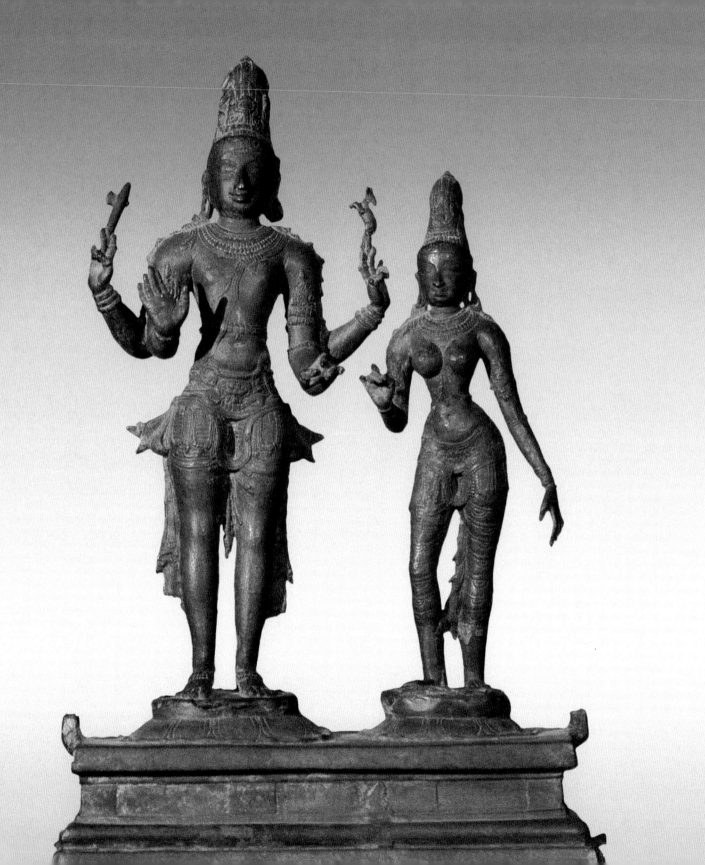

Shiva and Parvati

CHOLA, ELEVENTH CENTURY AD

BRONZE, SHIVA HEIGHT 50 CM, PARVATI HEIGHT 41 CM

TANJORE, TAMIL NADU

NATIONAL MUSEUM, NEW DELHI

The divinities stand on separate lotus pedestals placed on a shared rectangular base. Most frequently represented as separate images, though placed next to one another, here they remain separate, yet together as a processional icon. This version of the images is often entitled *Umasahita Candrasekharamurti*, meaning 'Uma', another name of Parvati, the Goddess, 'with her Lord wearing the moon in his crown'.

Shiva stands straight, both feet solidly on his pedestal, strictly conforming to iconographic prescriptions. The battle axe is in his rear right hand and the antelope, its head turned away from him, leaps from the two upraised fingers of his rear left hand. His forward right hand makes the gestures of reassurance and the left of granting a boon. The leaping antelope symbolizes the sacrifice destroyed by the God in Vedic legend. It takes the form of the black antelope as it flees to heaven, and in sculpture, especially, in bronzes of Chola and later periods, provides an opportunity for the sensitive depiction of animals in action.

Parvati, the Goddess, and Shiva's consort despite her own importance and power, is, as is customary, a delicate feminine figure, only as tall as the shoulder of Shiva. She stands gracefully, her right knee slightly bent, her left arm swinging freely, while her right arm is partly raised as if the hand were holding the lotus sometimes depicted in her grasp.

Somaskanda

CHOLA, TENTH CENTURY AD

BRONZE, HEIGHTS: SEATED SHIVA 54 CM, SEATED PARVATI 42 CM, STANDING SKANDA 15 CM

TANJORE, TAMIL NADU

INDIAN MUSEUM, CALCUTTA

Shiva, Parvati and their son, Skanda, had been carved in stone for the rear wall of Pallava temples behind the *linga*, which was placed in the centre of the sanctum. It continued to be a favourite image during the Chola period, but cast in bronze. Present in every Shiva temple, the Somaskanda symbolized the perfect family, the care of the father and the mother for the son. An object of daily worship, but also used for processions during certain festivals, when the figures are clothed and decorated with jewellery, the Somaskanda was carried out of the temple for the people to see.

Skanda is represented as either standing or seated, while a powerful and confident seated Shiva towers over him to his right, and a tender Parvati sits to his left, looking towards Shiva. She is thought to intercede with the God on behalf of her votaries.

The figures are sometimes cast separately and frequently the small figure of Skanda is missing from examples exhibited in museums.

110

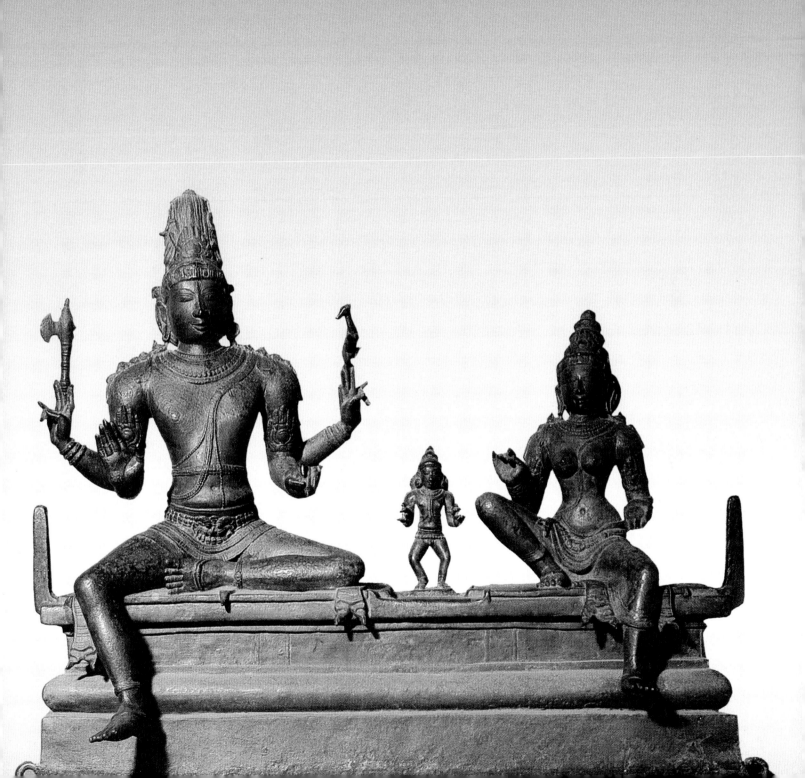

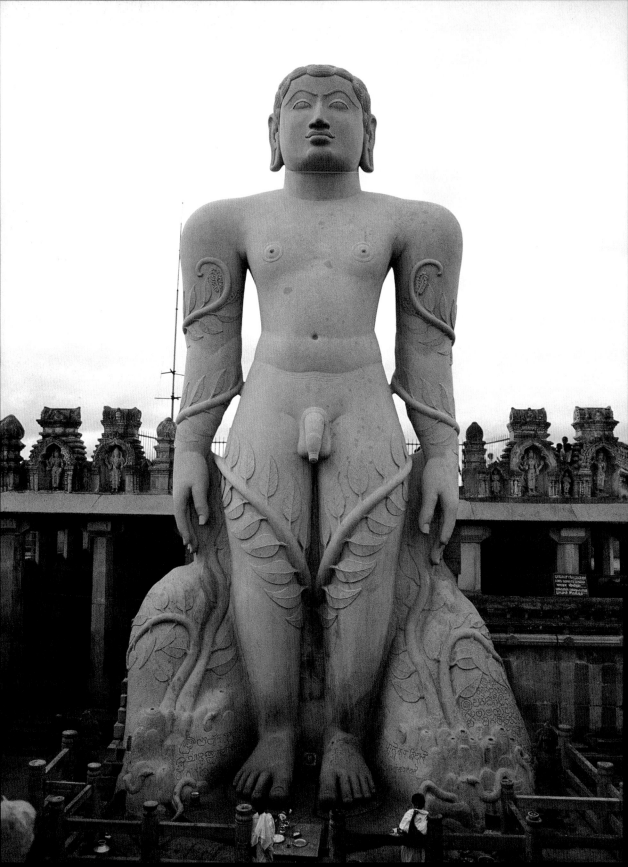

Saint Gommatesvara

GANGA, TENTH CENTURY AD
GRANITE, HIGHLY POLISHED, HEIGHT 17.5 M
SRAVANA-BELAGOLA, KARNATAKA
ADMINISTERED BY THE ARCHAEOLOGICAL SURVEY OF INDIA

The most striking of Jain sculptures are the colossal nude figures standing on hills dominating the temple complexes erected around them. The best known and tallest is the Gommatesvara, the Bahubali, at Sravana-Belagola, Karnataka. Carved in granite at the top of Indragiri hill, it is represented in meditation, so intensely absorbed and motionless that creepers grew around the legs and arms almost to the shoulders. The sculpture presents him as young and robust, despite the austerities that he has practised, confident, and smiling benignly. The statue was commissioned by Chavundaraya, the minister of Pachamalla Satyavokya (c. 974–84) of the Ganga dynasty. Its thousandth anniversary was celebrated during several days of elaborate ablutions in February 1981, in the presence of devout pilgrims.

Around the feet of the statue, a pillared cloister, built later, shelters images of the Tirthankaras. Other structures serving the religious requirements of the Jains have been erected on the hill and at its base.

Neminatha: A Tirthankara

CHAHAMANA, TWELFTH CENTURY AD
BLACK BASALT, HEIGHT 119 CM
NARHAD, RAJASTHAN
NATIONAL MUSEUM, NEW DELHI

By exception wearing a brief lower garment, held in place by a broad belt with flowing tassels, dignified and withdrawn, this tautly modelled image seems a symbol of the austerity and self-assurance of the Jain faith. The twenty-fourth and last Tirthankara of the present cycle of time, Mahavira, the 'Great Hero', was a contemporary of the Buddha and a parallel teacher of the way to salvation. The twenty-three earlier Tirthankaras, 'Ford Makers', are usually represented completely nude. They normally bear on the chest, as does this image, the *shrivatsa,* an auspicious diamond-like ornament. They stand rigidly with their arms held somewhat away from the body as is illustrated by this figure. The tight curls, the bun and the elongated ear lobes recall images of the Buddha. On each side, at this Tirthankara's feet, kneels a devotee and above each devotee stands the ceremonial fly whisk bearer.

114

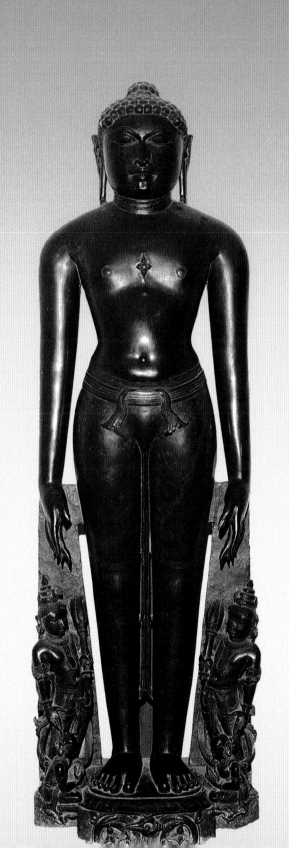

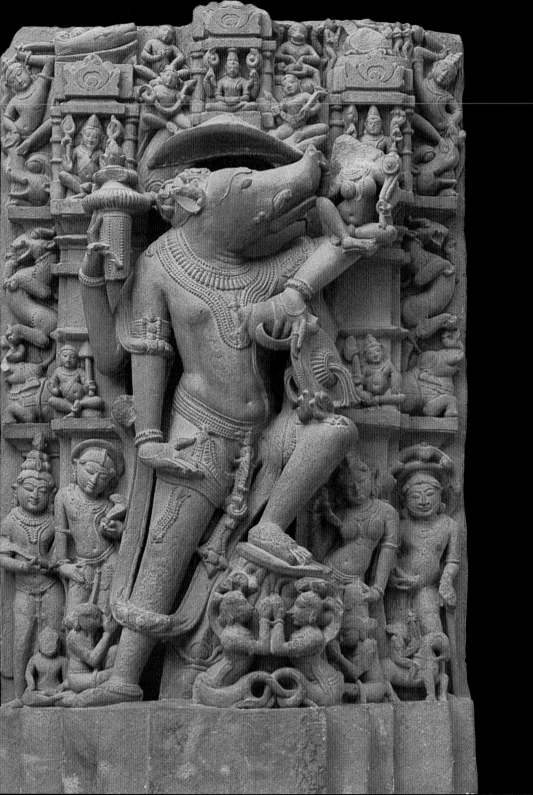

Varaha

CHANDELLA, ELEVENTH CENTURY AD
REDDISH SANDSTONE, HEIGHT 145 CM
KHAJURAHO, MADHYA PRADESH
ARCHAEOLOGICAL MUSEUM, KHAJURAHO

Vishnu, as the preserver of order in the universe, assumed when necessary, human or animal forms (*avatars*) in order to correct some abuse or some condition that threatened to disturb the order which he upheld. Thus *Varaha* or the Boar incarnation, was the third form taken by Vishnu, to rescue Earth from the Ocean in which she had been submerged and seemed likely to be lost forever. Here the great Boar is carved in high relief. He has dived deep into the watery depths, has found Earth and has surfaced with her in his arms. She is represented by a small female figure, her head unfortunately broken off, seated on the great animal's elbow of the forward left arm. The Boar nuzzles her gently while gods, mortals and worshippers, rejoice at the rescue. The God's left foot presses down firmly on the two snake divinities with outspread hoods representing the waters. His right rear hand grasps the mace; his left forward hand holds the conch. The right forward hand may have held some object, now broken off; the left rear arm is hidden by his pose. The Boar wears a broad collar around the throat and a long necklace of five-beaded strands falls over his chest. He has ornate armlets, beaded bracelets and anklets, and a broad beaded belt, a scarf with tassels supporting a brief dhoti. Earth has a long necklace and all the other figures wear jewellery. The Boar image is clearly powerful and as architectural decoration is monumental, but the details of the animal's head and figure are delicate and sensitively carved.

Dancing Ganesha

PANEL FROM A TEMPLE, TENTH-ELEVENTH CENTURY AD

BUFF SANDSTONE, HEIGHT 195 CM

KHAJURAHO, MADHYA PRADESH

ARCHAEOLOGICAL MUSEUM, KHAJURAHO

The elephant-headed God is represented here with many of his attributes. His mount, a rat, is below his right knee. He grasps the axe, his favourite weapon, with two of his right hands, while his front right arm and hand are in a graceful, relaxed, dancing position. The fourth right hand, to the rear, rests on the top of the axe handle, and appears to grasp a snake, rearing up near his right ear. The body of the snake encircles his head, but is broken half way around it. The front left hand holds a bowl piled high with globular candies, from which his trunk makes a selection, for he is very fond of sweets. The other left hands are damaged and what they hold is, in each case, difficult to identify. He wears abundant jewellery and a tasselled headdress, matched by the short scalloped dhoti, with tassels and a central pendant which sways as he dances. A female musician can be seen near the snake's head. Close to his left knee crouches a drummer and another behind the rearing rat on his right. A sage or worshipper sits on a bracket pedestal to his left.

Ganesha is a favourite deity to propitiate at the beginning of any enterprise for he is credited with the power to remove obstacles. He is particularly honoured in Maharashtra, where his annual festival ends with the immersion of his image.

Ganesha is considered to be one of the two sons of Shiva and Parvati. Parvati made him her doorkeeper. Shiva, who had left for a pilgrimage before Ganesha's birth returned home at the very moment Parvati had gone in for her bath. Failing to recognize him, Ganesha tried to prevent Shiva from entering her apartment. The angry God cut off his head. As Parvati was inconsolable at this tragedy, the gods agreed that Ganesha could be restored to life, if another head could be attached to the body. The first head to be found turned out to be that of an elephant.

Shiva made him the leader of the Ganas, his dwarf attendants, and therefore he is often called Ganapati.

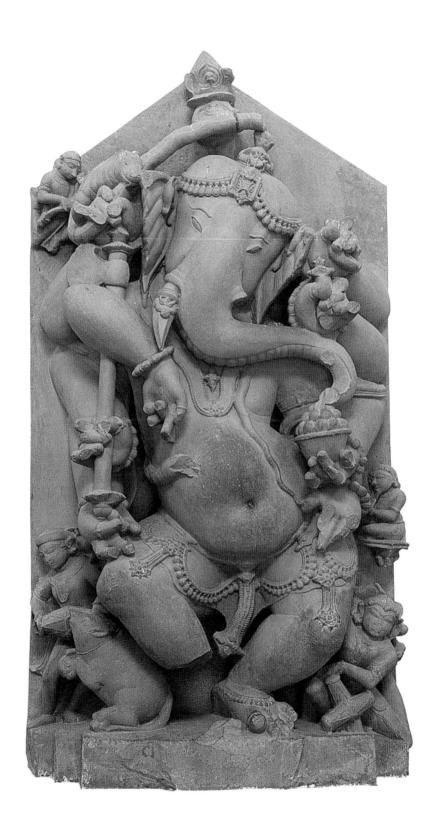

Girl Writing a Letter

CHANDELLA, ELEVENTH CENTURY AD

TAN SANDSTONE, COMPLETE FIGURE HEIGHT 89 CM, THIS DETAIL C. 55 CM

KHAJURAHO, MADHYA PRADESH

INDIAN MUSEUM, CALCUTTA

The statues of attractive young women engaged in various familiar actions represent the skill of the Khajuraho sculptors in depicting the human form in a diversity of postures. A favourite example, often made even more appealing to the spectator by the romantic suggestion that it is a love-letter which the girl is engaged in writing, is this figure on exhibition in the Indian Museum, Kolkata. This detail of the sculpture illustrates well how the twist in the body, to provide a good view of the girl's action, appears quite a natural pose, though it required keen observation and consummate skill from the sculptor.

The Hindu and Jain temples of Khajuraho are lavishly decorated with sculptures, band above band of men and women in a great variety of activities on the exterior walls and free-standing statues to provide a contrast of scale and to introduce variety as in this bracket figure from the interior, where the ceilings, walls and the doorways are also enriched with sculptures of appropriate themes.

120

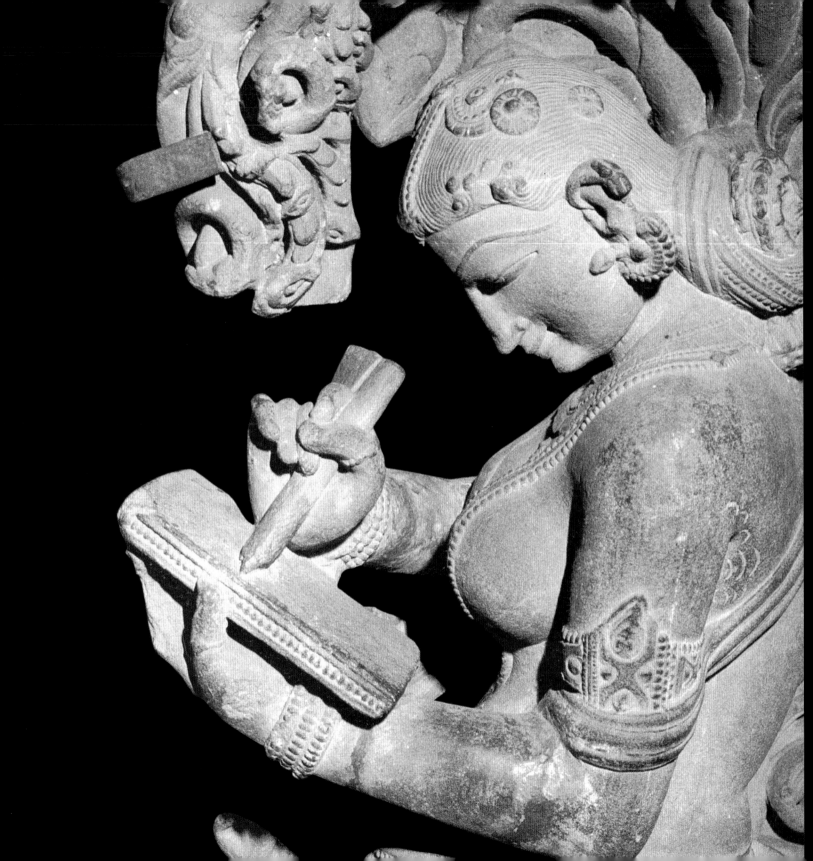

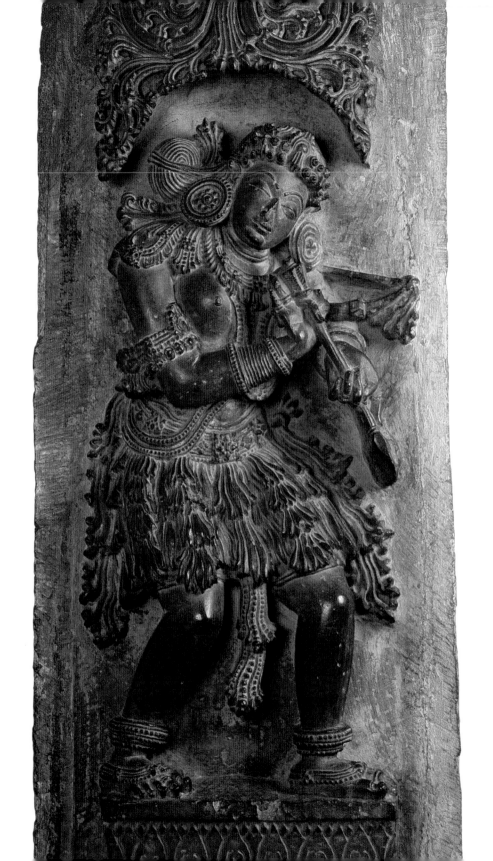

Huntress

HOYSALA, THIRTEENTH CENTURY AD
DARK STEATITE, HEIGHT 120.5 CM
MYSORE, KARNATAKA
NATIONAL MUSEUM, NEW DELHI

The Hoysala chieftains, earlier subject to the Chalukya kings, came into prominence in the region of Mysore, now the State of Karnataka, in the twelfth century. Approximately at the same time the Cholas, who lost their dominance over south India, yielded to their rivals, the Pandyas who set up their capital at Madurai.

Under the Hoysalas, important temples of distinctive ground-plan and architectural design, lavishly decorated outside and inside with sculptures, were constructed during the twelfth and thirteenth centuries, notably at Halebid, Belur and Somnathpur. The star-shaped platform, providing, as at Somnathpur, a broad circumambulatory path around the temple, established a corresponding pattern for the building's walls, which thus had projecting and receding surfaces and angles to be covered with decorative carvings.

Besides larger figures, like the Huntress, the exterior walls were covered with bands of animals and men in processions. The local building material employed for these temples, steatite or soapstone, soft when unearthed, and easily carved in minute details, which hardened and darkened in colour when exposed to the air, contributed to this innovation in the style of sculpture. The Huntress, sallying forth clothed in a short skirt of leaves, has a typical canopy of intricately sculptured vegetation. She undoubtedly represents some tribe inhabiting the region during that time.

The Enlightenment

PALA, ELEVENTH CENTURY AD
BLACK BASALT, 52 X 28 CM
BIHAR, NORTH INDIA
NATIONAL MUSEUM, NEW DELHI

Symbolically seated on a lion throne, this image of the Buddha in the black basalt of Bihar, depicts him stretching his right hand out over his seat in the gesture of 'calling the earth to witness' that he had not for a moment been distracted from the deep meditation that resulted in his 'Enlightenment'. He wears a transparent upper garment over the left shoulder and arm, leaving the right bare. The heavier undergarment tied at his waist can be seen, with the hem of both garments showing at the ankle of the right leg. The head, covered with tight curls, and with a protuberance on his head, stands out in bold relief against a round halo on which the foliage of the pipal tree is suggested.

Soon after this image was carved, Buddhist establishments in north India were wiped out and this last echo of Buddhism disappeared, leaving behind only ruins, as at Nalanda.

At this late period the image and the symbols of the Buddhist faith have less of the charm and grace characteristic of the Gupta period. Dignity and formality dominate.

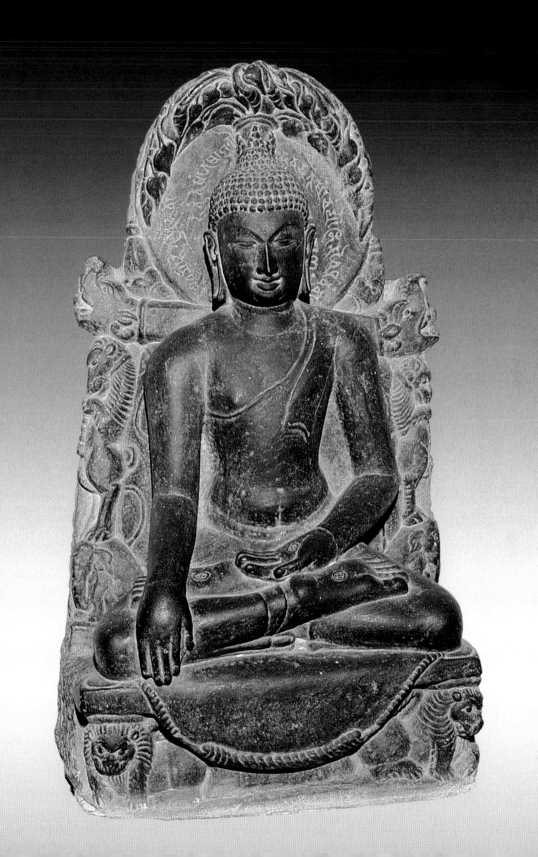

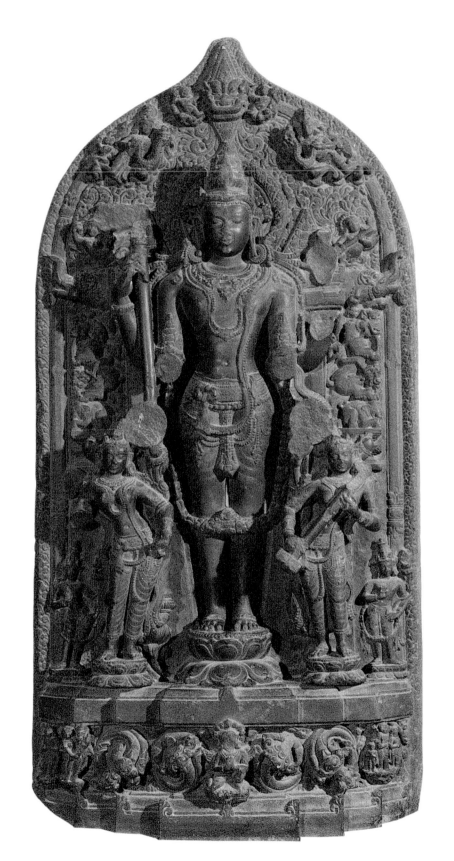

Vishnu and His Consorts

PALA, ELEVENTH CENTURY AD
BLACK BASALT, 70 X 38 CM
BENGAL
NATIONAL MUSEUM, NEW DELHI

Vishnu, broad shouldered and powerful, stands firmly at the centre of the panel, grasping the mace in his right rear hand, the discus in his left rear hand, and the conch in the left forward hand. The right forward hand is in the gesture of bestowing gifts. The image wears a high crown and above it is the stylized 'lion's head of glory', a decorative feature typical of the sculptures of this period in north India, the region corresponding to the modern states of Bihar and West Bengal. At his right is his consort Lakshmi, the Goddess of Good Fortune and Prosperity and at his left Saraswati, the Goddess of Learning and the Arts who holds the *veena,* a stringed musical instrument, her usual attribute. The high pedestal is crowded with worshippers and decorative detail. The God wears a thin lower garment falling to the knees and both Goddesses have similar transparent skirts. All three figures are decorated lavishly with jewellery. The black stone is highly polished. The icon has great dignity and conveys fully the majesty of the God, in his role of preserver of order and stability, with the consorts to suggest the benign aspects of his power.

127

Girl Playing with Balls

SOLANKI, ELEVENTH CENTURY AD
MARBLE, HEIGHT 101 CM
WESTERN INDIA, NAGDA, RAJASTHAN
NATIONAL MUSEUM, NEW DELHI

The graceful figure of the girl, twisted in what appears a natural pose justified by her activity, continues the tradition of the Yakshi, the female tree spirit. Grasping a branch above her head and another, lower down, with her left hand, she wears the abundant jewellery of her period around her neck, on her upper arms and wrists, at her waist and on her ankles and feet. A small female figure on her right receives the balls and returns them to her, while on her left a similar small male figure plays a flute to give rhythm to the game.

The girl has a quiet smile. Is there an umbrella above her head? Is she a young princess amusing herself?

The slab decorated a temple, but the Yakshi is to be considered a secular figure, not a divinity, and conforms to the ornate decorative style of its period and place.

128

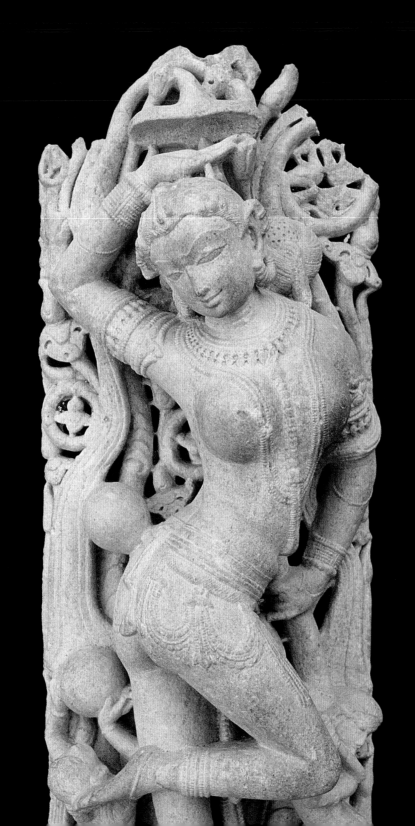

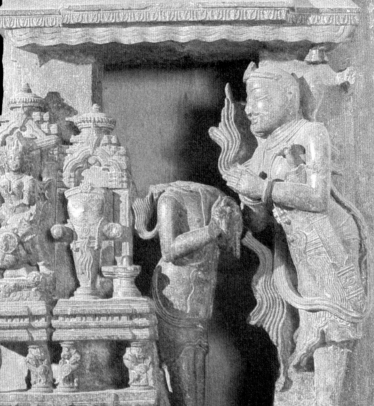
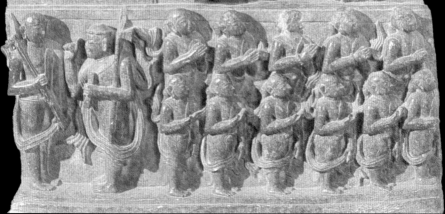

King Narasimhadeva Worshipping

EASTERN GANGA, THIRTEENTH CENTURY AD

DARK CHLORITE, 89 X 40.5 CM

KONARAK, ORISSA

NATIONAL MUSEUM, NEW DELHI

The King stands at the right with hands joined, his long sword at his left side. He is adorned with necklaces, arm bands, bracelets and anklets. He addresses the shorter, now headless priest, in a brief dhoti, standing before him at the centre of the scene, clasping his hands in the gesture of respect and worship. His back is turned to the platform on which are set religious icons, beneath an architectural decoration based on the distinctive style of the Orissan temple. The *linga* and the image of Jagganatha of Puri are unmistakable.

Below this major scene are a guard and a palace official giving him instructions, and two rows of men, facing right, in the attitude of worship and respect, doubtless courtiers and attendants. The panel is surmounted by an architectural decoration in two tiers, with central projections, lions at the top, and, in the centre, a *kalasha*, the water pot. A bird perches at either end of the upper tier.

This panel and others, depicting the activities of King Narasimhadeva, were placed in niches on the exterior of the sanctum of the Sun Temple at Konarak. A proud King, a triumphant leader of armies repelling invaders, King Narasimhadeva (c.1238–1264) commissioned the Sun Temple at Konarak. Its size, its lavishly sculptured exterior and the originality of its conception as the chariot of the Sun God, on twelve sculptured wheels drawn by seven galloping horses, makes it unique. It is the brilliant culmination of the uninterrupted evolution, for some five centuries, of the distinctive architectural temple style of Orissa.

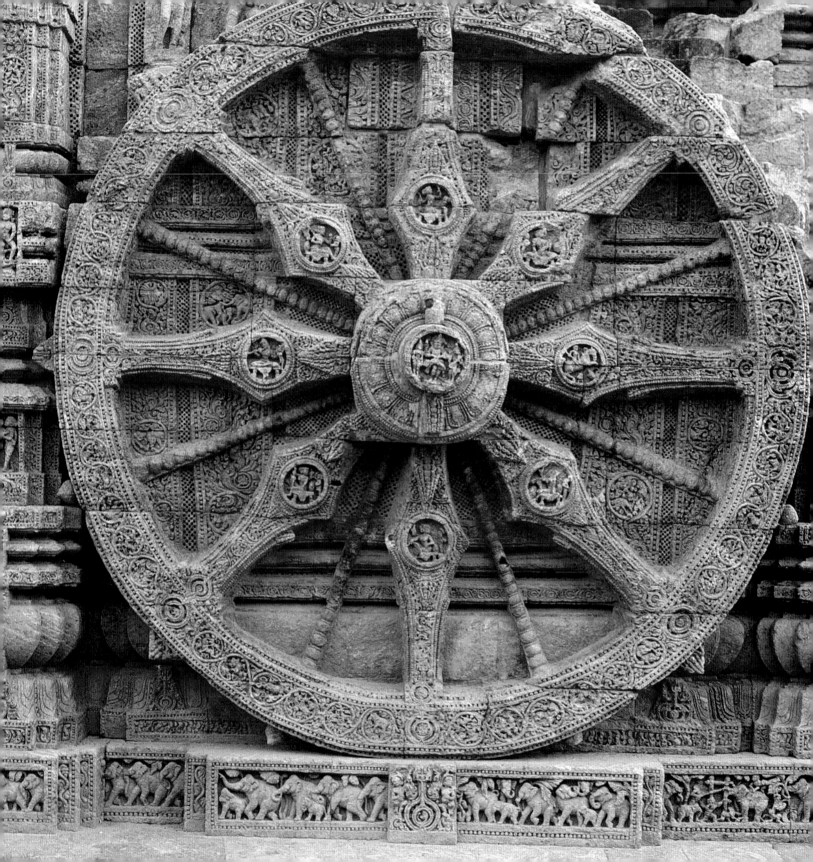

Wheel of the Sun Temple, Konarak

EASTERN GANGA, THIRTEENTH CENTURY AD

CHLORITE, HEIGHT OVER 4 M

KONARAK, ORISSA

ADMINISTERED BY THE ARCHAEOLOGICAL SURVEY OF INDIA

An examination of a wheel of the chariot of Surya, and of a section of the platform against which it is placed, provides a good idea of how adroitly smaller scale decorative ornamentation was applied.

All wheels follow the same pattern, but their decorative details differ. They all have a hub in which a pin is inserted to hold the axle in place, as in a real cart. Eight spokes are straight and slender, formed by alternate beads and discs. The other eight are wide, and, as they approach the hub, they broaden to form a diamond-like portion in which a medallion with figures is placed. The band forming the outer rim is decorated with creepers, sometimes with figures of men or women or animals added to them and the band around the hub has decorations. The hub itself forms a medallion for figures. The wheels rest on a narrow moulding, depicting men or animals in a procession; in this case, elephants follow one another, in some variation of poses.

The platform behind the wheels is divided into sections by vertical pillar-like projections, and into horizontal bands, decorated by stylized plant forms, with figures of various sizes engaged in a variety of activities.

133

Karatalas Player, Sun Temple, Konarak

EASTERN GANGA, THIRTEENTH CENTURY AD

CHLORITE, HEIGHT OVER 4 M

KONARAK, ORISSA

ADMINISTERED BY THE ARCHAEOLOGICAL SURVEY OF INDIA

The roof of the entrance hall or porch (*pidha deul* in Orissan architectural terms), composed of horizontal terraces diminishing in size to form a pyramidal silhouette, is embellished with a variety of life-size and larger than life figures. Most charming among them are the thirty-two young women musicians, sixteen on each of the two terraces, playing a variety of instruments. Somewhat larger than life, they stand in graceful dance poses as they mark the rhythm of the dance. Thus, this player of the large metal cymbals fastened with strings, called *karatalas*, seems lost in the pleasure of marking time. Her lower garment, so fine a weave as to appear transparent, gathered into pleats in front, falls between her legs from the low broad belt and appears to sway with her. Her expression is serene and detached, but like all her companions, she seems an individual, carefully observed and depicted vividly as a personality known and admired. She wears the ornate jewellery of her place and time. Behind her at her right some distance away, is the silhouette of another musician.

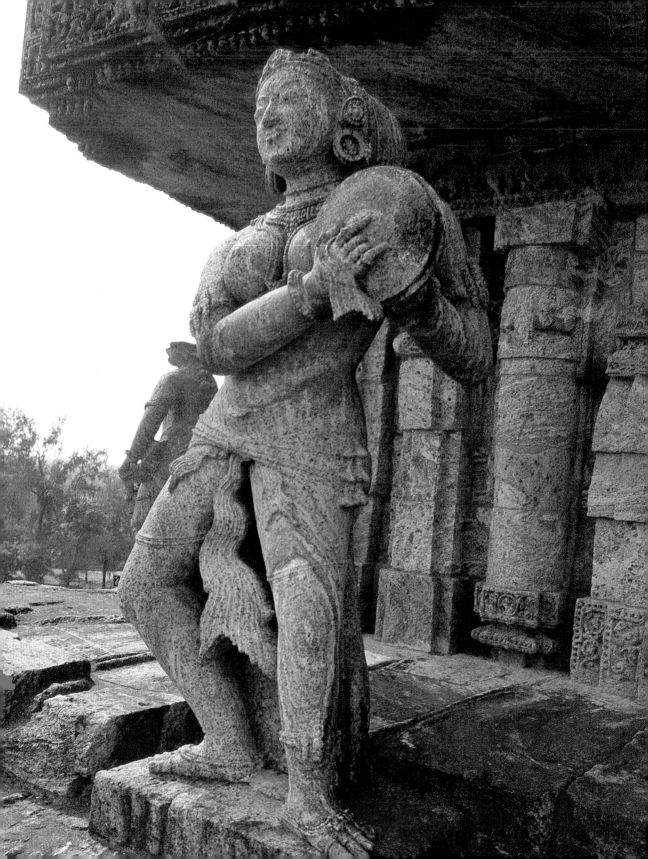

Colossal Elephant, Sun Temple, Konarak

EASTERN GANGA, THIRTEENTH CENTURY AD

STONE, HEIGHT 2 M

KONARAK, ORISSA

ADMINISTERED BY THE ARCHAEOLOGICAL SURVEY OF INDIA

The Sun Temple, with its sanctuary and the lofty tower above it (*rekha deul*), to be entered through its porch or entrance hall (the *jagamohan, bedha deul*), roofed by horizontal sections and terraces in pyramidal form, was erected in the thirteenth century by King Narasimhadeva of the Ganga dynasty. It surpassed its predecessors in size and the lavish ornamentation of its exterior. Both colossal sculptures and small-scale carving, rich in detail, make appropriate contributions to the Temple. Larger than life-size female musicians in graceful dance poses decorate the terraces of the porch. Originally pairs of huge animals—a lion on an elephant, a pair of horses and a pair of elephants—guarded the approaches to the stairways of the porch. This colossal elephant holding a figure with sword and buckler, perhaps ready to hurl him away, is one of a pair placed near the north stairway.

The animal is elaborately decorated, with a head ornament, a caparison with tassels, and anklets. The sculptor's understanding and feeling for the modelling of the huge beast reveal great sensitivity.

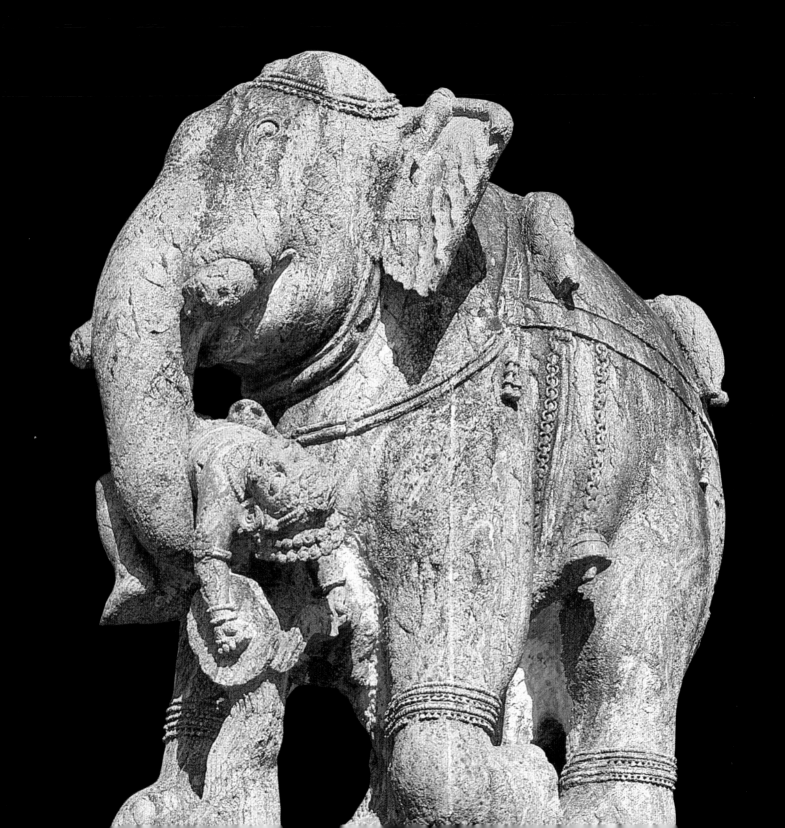

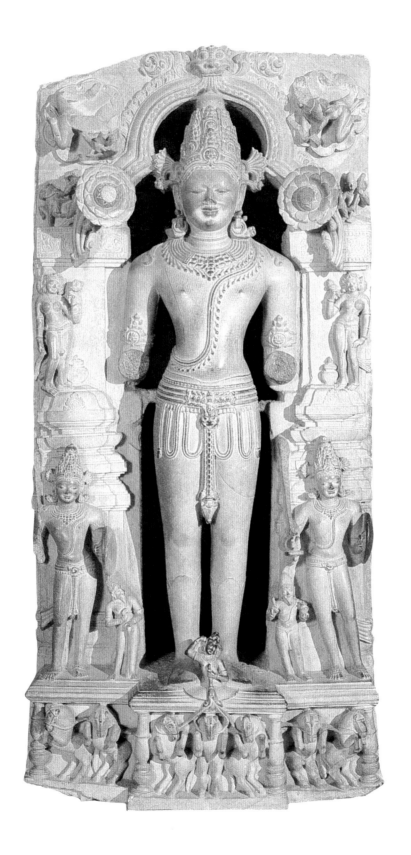

Surya, the Sun God

KESARI DYNASTY, LATE TWELFTH CENTURY AD

PALE CHLORITE, HEIGHT 188 X 89 CM

KONARAK, ORISSA

NATIONAL MUSEUM, NEW DELHI

The image of Surya stands on a platform representing his chariot. Between his feet, the charioteer Aruna (only his torso remains) cracks his whip and holds the reins of the seven galloping horses depicted in full career below. Surya smiles benignly, under his high crown. The forearms and hands which held the lotus blossoms carved above each shoulder, are lost, but otherwise no detail of the sensitively sculptured image and its setting is missing or damaged. The short transparent dhoti of the God is held in place by an elaborate belt with ornamental beaded loops, and a central pendant, falling from a clasp in the form of a lion's head, down almost to the top of the high boots. A delicately carved thin coat of mail protects the torso, while over it fall rich ornaments — a beaded necklace with a central clasp and the sacred cord of three strings of beads with multiple pendants. In addition, he wears a band of beads at the base of the throat and ornamented armlets. Beside his feet on the structure which frames him are his bearded attendants, Dandi and Pangala, while towering above them are tall warriors, armed with swords and shields against an architectural motif recalling a miniature temple. Above them on either side stands a young woman holding a lotus stalk. Surya's head is framed by an arch with flames springing from a pedestal at either side, with a *veena* player on the right and a man with a sword on the left. At its apex is the lion head motif. On the corner above on each side is a flying figure, the familiar *vidyadhara*, the flying flower-showering attendant of the God.

This image of Surya, distinguished in quality, sensitive in modelling and in the treatment of surface detail, assured in design, despite the complexity of its symbolism of many figures of varying scale, rich in ornamentation, is believed not to belong to the main Sun Temple but to the small ruined temple to the west-southwest discovered when clearing sand and debris from the site.

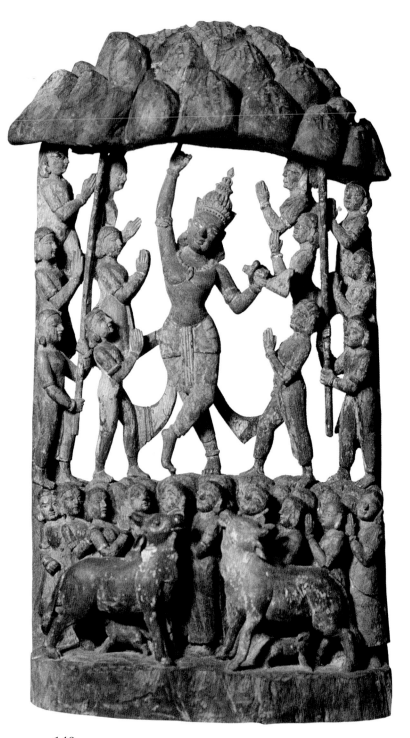

Krishna Lifting Mount Govardhana

EIGHTEENTH CENTURY AD

WOOD, 84 X 43 X 21 CM

ORISSA

NATIONAL MUSEUM, NEW DELHI

The stories of Krishna's miracles have inspired artists to depict them dramatically in various media and styles in different parts of the country at many periods. A favourite, often portrayed in miniature paintings, is Krishna holding aloft Mount Govardhana as a sort of umbrella to shelter the people of Vrindavana from the torrential rain released by Indra. In the *Bhagavata Purana* it is stated that Krishna persuaded the people to turn from their traditional worship of Indra and this downpour was Indra's effort at punishing them and getting them back into the fold. Krishna, undisturbed, lifted Mount Govardhana on his little finger to serve as a shelter for the people and their cattle. He thus defeated Indra and won even greater love and devotion from his companions.

This wood carving in high relief presents the miracle effectively. Krishna, holding up the mountain with his left hand, stands in a familiar dance pose, with his male and female cowherd companions on either side, adoring him. A crowd of people stand below in admiration and gratitude, and two cows and their calves are likewise sheltered. Only traces of the paint which must have made the carving a colourful decoration still remain.

Krishna with His Flute

EIGHTEENTH CENTURY AD
IVORY, HEIGHT 22.5 CM
ORISSA
NATIONAL MUSEUM, NEW DELHI

Krishna, in the gesture of holding the flute, his feet crossed in a dance pose, is a familiar and well-loved image. He stands here on a high lotus pedestal, crowned, with earrings, arm bands, bracelets, anklets, and a jewelled belt, of several bands and loops over his thighs. His garment and tassels fall from the shoulders and the lower ends sway as he dances. The flute is missing. It was probably carved separately, or it may have been made of another material and fitted into the outstretched hands.

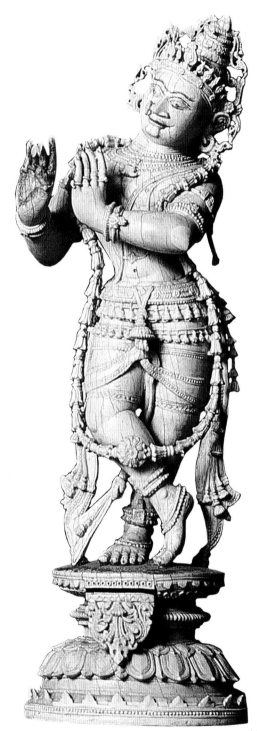

141

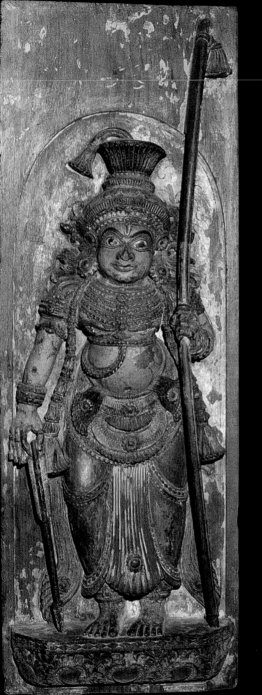

Rama

EARLY NINETEENTH CENTURY AD
POLYCHROME WOOD, HEIGHT 120 CM
KERALA
NATIONAL MUSEUM, NEW DELHI

Rama, grasping his bow in his left hand, holds arrows in his right. His hair is piled high to form a sort of crown; he wears jewellery. His dhoti of thin material falls to his ankles from a sash and broad decorated belt, and is gathered into pleats in front.

It is interesting to note that in pose and in dignity of bearing, this image from the decoration of a village temple, recalls the scene sculptured, more than a thousand years earlier, in dark red sandstone in the Dasavatara Temple of Deograh, in which Rama has released Ahalya from her husband Gautama's curse.

Garuda

EARLY NINETEENTH CENTURY AD
CARVED AND PAINTED WOOD, 48.5 X 37 CM
KERALA
NATIONAL MUSEUM, NEW DELHI

The vehicle of Vishnu is the Garuda or eagle, a winged figure, represented in a variety of ways at different periods and places, often with a human body and bird's head, or a human head, with a beak. Traditionally it is supposed to be the enemy of snakes and captures and kills them.

This polychromed wooden ornament from a Kerala temple presents an effective and decorative interpretation of the mythical creature in a folk style. The reference to snakes is made at the two lower corners. The pendant decorations falling from each shoulder recall some details of the Kathakali dance costume. The upraised arms suggest the strong wings, and the staring eyes, its alertness to the major role it plays in relation to the deity.

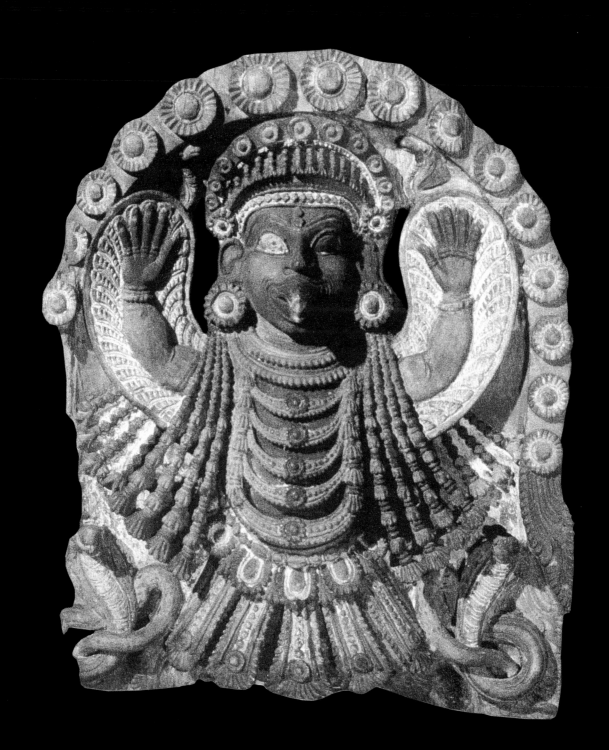

LIST OF ILLUSTRATIONS